IMAGES
of America

RICHMOND

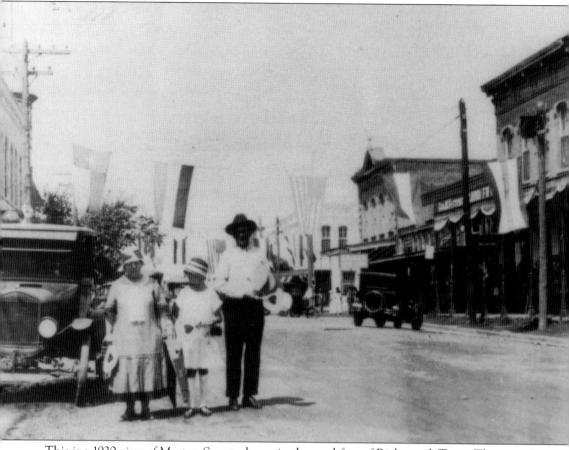

This is a 1920 view of Morton Street, the main thoroughfare of Richmond, Texas. The street is named in honor of William Morton, one of Stephen F. Austin's "Old Three Hundred" colonists. An Alabama native, Morton arrived in the area with his family in 1822 and received grants on both sides of the Brazos River, including part of the future town site of Richmond. Morton drowned during a flood of the Brazos River in 1833. Also named in his honor was the Morton Masonic Lodge 72 AF&AM, organized in 1850 and chartered in 1851.

ON THE COVER: This photograph shows the C.D. Myers Grocery, Hardware, and Feed Store around 1908. Three men are standing in front of a hitching post with two children sitting on it. The children are Randolph and Clem Jr., sons of Clem D. Myers and his wife, Mattie. Store owner Clem Myers is to the right of his children, followed by Sanford J. Butler. The man on the left is unidentified. In addition to his mercantile business, Myers served as county clerk four times between 1907 and 1946. He also served as county judge (1921–1924), justice of the peace (1929–1932), and county auditor. The store remained in operation until 1914. Butler came to Richmond in 1893 with his grandparents, who raised him, and his uncles—Josh, Jenks, and Lewis Adams—who later owned the Three Brothers Saloon in Richmond (page 51). In 1917, Butler began working abroad in the oil fields for The Texas Company. While in Tampico, Mexico, he registered for the World War I draft, serving in Europe in the 320th Repair Unit of the Motor Transport Corps. After the war, he returned to the oil fields in Mexico, living intermittently with his uncle Josh and aunt Jennie on N. Second Street in Richmond. Sanford retired from the oil fields and married Willie Henderson Mathews of Richmond, became superintendent of the Richmond Water Department, and had two sons.

IMAGES
of America

RICHMOND

Clinton Drake and Theresa Jach

ARCADIA
PUBLISHING

Published by Arcadia Publishing
Charleston, South Carolina

Printed in the United States of America

Library of Congress Control Number: 2013949942

For all general information, please contact Arcadia Publishing:
Telephone 843-853-2070
Fax 843-853-0044
E-mail sales@arcadiapublishing.com
For customer service and orders:
Toll-Free 1-888-313-2665

Visit us on the Internet at www.arcadiapublishing.com

*We would like to dedicate this book to all of the people
in Richmond, Texas, who keep its history alive.*

CONTENTS

ACKNOWLEDGMENTS

We would like to thank the Fort Bend County Museum, especially Chris Godbold, curator of collections, for ongoing assistance and accommodation with obtaining photographs for this book. We would also like to thank the staff of the genealogy and local history department at the George Memorial Library in Richmond; the library permitted the use of donated photographs, largely from the 1986 City of Richmond Sesquicentennial Committee. Unless otherwise noted, the photographs in this volume appear courtesy of the Fort Bend County Museum (FBCM). Images labelled (FBCL) are courtesy of Genealogy and Local History Department, Fort Bend County Libraries.

INTRODUCTION

In the early 1820s, the Spanish government, spurred by desires to buffer the northernmost territories of Spanish-controlled Mexico from Indian attacks and to advance social and economic growth, opened the area to settlement by foreigners. The Spanish government contracted with land agents, or *empresarios*, such as Moses Austin, who was granted an application to settle 300 families in Tejas in January 1821 but died in June before he could fulfill the contract. After Mexico gained independence from Spain in August 1821, Moses Austin's son, Stephen F. Austin, successfully sought permission from the new government to resume the colonization contract granted to his father, and colonists began to arrive shortly after.

On November 25, 1821, 20 men who contracted with Austin for land in exchange for labor left New Orleans for the colony aboard the schooner *Lively*; they were to meet Austin at the mouth of the Colorado River. After being blown off course and lost at sea, the crew mistook the mouth of the Brazos River for that of the Colorado, sailed upstream near the present site of Richmond, and built a log stockade that gave the small area its first namesake: Fort Bend, or the Fort Settlement. Many from the party returned to the United States when food became scarce. The group eventually reestablished communication with Austin, and other settlers begin to arrive at the Fort Settlement to settle their land grants in the area.

In 1822, the settlers built a small log fort on the west bank of the Brazos. For the next two years, colonists remained in the vicinity of the fort, and in 1824, the Mexican government officially issued land grants to the colonists. This original settlement was known as the Fort Settlement through much of the Texas Colonial period.

As tensions mounted between the Mexican government and colonists, Texas leaders formed a temporary government that culminated in the Texas war of independence from Mexico in 1836. Mexican troops led by General Antonio López de Santa Anna proceeded south down the Brazos. Intelligence of the approaching army led the settlers to abandon Fort Bend/Settlement on April 1, 1836. Part of the Mexican army came through Richmond, bivouacking at Thompson's Ferry, while others continued on, eventually meeting defeat against Gen. Sam Houston's army at San Jacinto, marking the dawn of the Republic of Texas.

On February 21, 1836, business partners Robert Eden Handy and William Lusk of Brazoria purchased the *labor* of land (about 177 acres) granted to William Morton as a colonist from his widow, Nancy (Pettigrew) Morton for $800. The land included Fort Bend, or the Fort Settlement, and later added a parcel of land purchased from Susan (Randon) Parker in the Jane H. Long grant. The settlement was referred to by the new name of Richmond as early as November 1836, when John V. Morton advertised his new ferry. By 1837, the town had been surveyed using the grid system, lots had been sold, and the city was incorporated in April 1837. By December, Fort Bend County was formed, and the citizens voted to make Richmond the county seat on January 13, 1838. The Brazos River, with its winding course through Fort Bend County, nearly doubled the profitable river frontage and served as an important transportation artery in trade centered

on the Gulf of Mexico for both the local area and areas farther north as goods passed through Richmond on their way to market.

The earliest establishments in Richmond were the grocery and dry goods business of Handy and Lusk (1836); James Riddell, gunsmith and cutler (1837); the *Richmond Telescope and Texas Literary Register* (1839); and St. John's United Methodist Church. The area developed slowly throughout the 1840s and grew in importance as a river port. Richmond's first courthouse was constructed in 1849. By the 1850s, the city contained the Richmond Male and Female Academy, a Masonic lodge, and several businesses. A yellow fever epidemic struck in 1853, but fortunes shifted upon completion of the Buffalo Bayou, Brazos & Colorado Railway line from Stafford's Point to Richmond, spurring development and ensuring prosperity. By the end of the 1850s, Richmond was a flourishing shipping and market center for surrounding plantations, with businesses from Fort Bend, Colorado, and Wharton Counties passing through or at least paying tribute as goods were transported to markets in Galveston and Houston. Although the Civil War did not reach Richmond, many men joined Confederate companies, and the economy was greatly devastated. After the Civil War, the Freedmen's Bureau, a federal government agency that aided emancipated slaves with transitioning to freedom, established an office in Richmond.

For the first time, the African American majority was able to hold political offices, marking a dramatic shift in power dynamics. The established white elite were now reliant upon African American votes in order to attain public office. The shift led to a fissure in the Democratic Party between the Jay Birds and Woodpeckers. The Woodpeckers formed partnerships with African American voters and politicians, who were Republicans, and ran for office on the Republican ticket. The Jaybirds viewed the Woodpeckers' actions as "dirty politics," and hostilities developed between the two groups, culminating in a shoot-out on the streets of Richmond in 1889.

The city continued to prosper throughout the 1880s and 1890s, with many new businesses reflecting the transformation of the local economy. Despite a vital business district, the population declined from 2,000 in 1880 to 1,500 in 1890 and to 1,180 by 1904, largely due to the development of the new town of Rosenberg, which was created when the Gulf, Colorado & Santa Fe Railway line bypassed Richmond. In 1899, a major flood engulfed the town. Later that year, the Richmond Cotton Company was incorporated and later formed the Richmond Electric Company to electrify area homes and businesses.

Sharecropping replaced plantation agriculture, and new crops—predominately rice—enhanced the local agricultural and ranching economy. Four local doctors established a hospital in Richmond in 1919, but it burned down later that year.

The discovery of oil and mineral resources in Texas defined the 20th century, restoring lost fortunes, creating new ones, and further securing the local economic base. The Great Depression affected the economy, along with the implementation of many New Deal agricultural programs. In the 1930s, the city extended sidewalks throughout the town, built a municipal pool, and approved an extensive bond package for further civil improvements. Richmond's adult male population declined once again with the onset of World War II, as many soldiers left town to serve in overseas campaigns. The economy suffered because capable harvest and production hands were few and far between—despite the utilization of German prisoners of war. After World War II, Richmond gradually recovered, and the area slowly evolved into a bedroom community for commuters traveling to jobs in Houston. Richmond has continued to cultivate its new natural resource—the city's proximity to Houston—while maintaining its own distinct culture and identity.

One

INFLUENTIAL AND
INFAMOUS CITIZENS

Robert Eden Handy (1807–1838) was born in
Pennsylvania and came to Texas in 1834. During
the Texas Revolution in 1836, he served as a
private in Capt. Robert J. Calder's Company K
of Col. Edward Burleson's 1st Regiment, Texas
Volunteers, and fought at the Battle of San
Jacinto. Along with William Lusk, he was the joint
founder of Richmond. He died in Richmond and
was buried there, probably in Morton Cemetery.
Mirabeau Lamar, vice president of the year-old
Republic of Texas, wrote that he "mourned the
loss of his best friend." After a personal plea
from his sister to Lamar, Handy's remains were
relocated to Laurel Hill Cemetery in Pennsylvania.
James Hutchins Handy was born to his widow,
Nancy (Graham) Danforth, after his death.
(Robert E. Handy; Accession ID: CHA 1989.075;
Courtesy State Preservation Board, Austin,
TX; Original Artist: Unknown; Photographer:
Eric Beggs, 8/16/97, post conservation.)

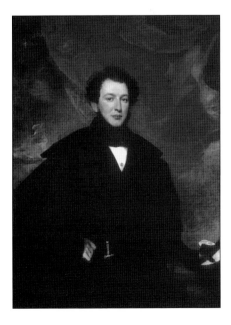

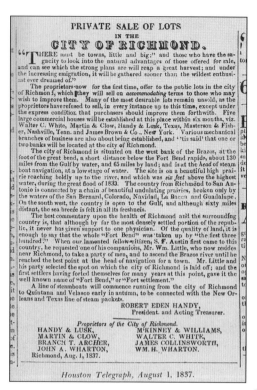

PRIVATE SALE OF LOTS
IN THE
CITY OF RICHMOND.

"THERE must be towns, little and big;" and those who have the sagacity to look into the natural advantages of those offered for sale, and can see which the strong points are will reap a great harvest; and under the increasing emigration, it will be gathered sooner than the wildest enthusiast ever dreamed of."

The proprietors now for the first time, offer to the public lots in the city of Richmond, which they will sell on *accommodating* terms to those who may wish to improve them. Many of the most desirable lots remain unsold, as the proprietors have refused to sell, in every instance up to this time, except under the express condition, that purchasers should improve them forthwith. Five large commercial houses will be established at this place within six months, viz. Walter C. White, Martin & Clow, Handy & Lusk, Texas, Masterson & Fisher, Nashville, Tenn. and James Brown & Co.. New York. Various mechanical branches of business are also about being established, and "'tis said' that one or two banks will be located at the city of Richmond.

The city of Richmond is situated on the west bank of the Brazos, at the foot of the great bend, a short distance below the Fort Bend rapids, about 130 miles from the Gulf by water, and 65 miles by land; and is at the *head* of steam boat navigation, at a low stage of water. The site is on a beautiful high prairie reaching boldly up to the river, and which was *six feet* above the highest water, during the great flood of 1833. The country from Richmond to San Antonio is connected by a chain of beautiful undulating prairies, broken only by the waters of the San Bernard, Colorado, Navidad, La Bacca and Guadalupe. On the south west, the country is open to the Gulf, and although sixty miles distant, the sea breeze is felt in all its freshness.

The best commentary upon the health of Richmond and the surrounding country is, that although by far the most densely settled portion of the republic, it never has given support to one physician. Of the quality of land, it is enough to say that the whole "Fort Bend" was taken up by "the first three hundred." When our lamented fellow-citizen, S. F. Austin first came to this country, he requested one of his companions, Mr. Wm. Little, who now resides near Richmond, to take a party of men, and to ascend the Brazos river until he reached the best point at the head of navigation for a town. Mr. Little and his party selected the spot on which the city of Richmond is laid off; and the first settlers having forted themselves for many years at this point, gave it the well known name of "Fort Bend," or "Fort settlement."

A line of steamboats will commence running from the city of Richmond to Quintana and Velasco early in autumn, to be connected with the New Orleans and Texas line of steam packets.

ROBERT EDEN HANDY,
President. and Acting Treasurer.

Proprietors of the City of Richmond.
HANDY & LUSK, M'KINNEY & WILLIAMS,
MARTIN & CLOW, WALTER C. WHITE,
BRANCH T. ARCHER, JAMES COLLINSWORTH,
JOHN A. WHARTON, WM. H. WHARTON.
Richmond, Aug. 1, 1837.

Houston Telegraph, August 1, 1837.

As Texas gained independence after the war with Mexico, increased confidence and perceived stability led to a surge in the prospecting and development of land. Hopes and dreams were larger than successes, with the Fort Bend towns of Fayetteville, Louisville, and Monticello fading away before they began. This newspaper clipping from the August 1, 1837, edition of the *Houston Telegraph* advertises the private sale of lots in Richmond; the city was incorporated in May 1837 along with 19 other towns in the Republic of Texas.

Erastus "Deaf" Smith (1787–1837) was so nicknamed due to a loss of hearing resulting from sickness. A celebrated spy during the Texas Revolution, he intercepted a dispatch at Harrisburg (Houston) that revealed the position of the Mexican army, greatly influencing the course of subsequent events. Smith relocated to Richmond after the war and established a land agency with Thomas H. Borden, but died shortly after on November 30, 1837. His burial site has been contested for over 100 years, but it was likely in the corner of the original Episcopal church lot, which was eventually paved over as Sixth Street. Legend claims that Smith requested to be buried vertically because he wanted to go out of this world the way he came in—head first. He was survived by his widow, Guadalupe (Ruiz) Smith, and three children. (Surrender of Santa Anna, detail of Deaf Smith; Accession ID: CHA 1989.046; Courtesy State Preservation Board, Austin, TX; Original Artist: Huddle, William H. 1847–1892; Photographer: unknown, pre-1991, pre-conservation. © State Preservation Board, Austin, Texas.)

Jane Herbert Wilkinson Long (1798–1880) came to Texas with her husband, Dr. James Long, who raised a private army to wrest Texas from Spanish control, joining him at his headquarters at Fort Las Casas on the Bolivar Peninsula. When her husband left to capture the town of La Bahia, Jane remained at the fort with her daughter, Ann, and slave Kian, refusing to leave even when her husband failed to return. She gave birth to a daughter, Mary James, earning her the sobriquet "The Mother of Texas" for the belief that she was the first white woman to give birth in Texas. As one of Austin's Old Three Hundred colonists, she received her land grant in Fort Bend County. She operated a boarding house (shown below) in town and a plantation with upwards of 19 slaves, including Kian and her descendants.

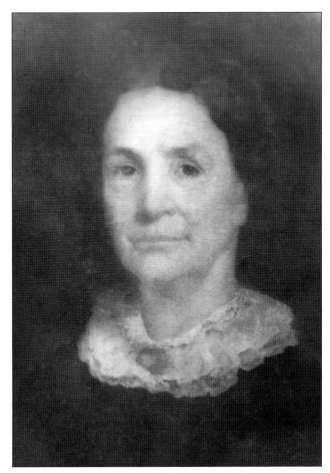

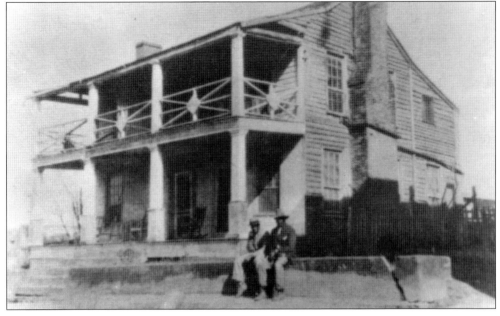

The Lamar-Calder home was built in the late 1850s, as shown by receipts for building materials in Mirabeau B. Lamar's probate record and papers pertaining to the Lamar family found in the attic by later owners Percy J. and Etta (Hunkin) Hendee. The house is referred to as the Lamar-Calder home because Mirabeau B. Lamar's daughter Loretto lived in the home with her husband, Samuel Calder.

This portrait shows Henrietta (Maffitt) Lamar (1827–1891), daughter Loretto (1853–1933), and a slave, possibly Fanny (Lamar) Richardson. After Henrietta's marriage to Mirabeau B. Lamar, former president of the Republic of Texas, in New Orleans in 1851, the couple toured the South, and their daughter Loretto Evalina "Lola" was born in Georgia. By early 1853, the Lamars had arrived in Richmond to establish a home, purchasing half of Jane Long's 1,000-acre plantation. Mirabeau had been acquainted with Long since his first trip to Texas in 1835. Henrietta was active in Richmond society, a devout member of Calvary Episcopal Church, and is remembered for her charity to Confederate soldiers and their families during the Civil War. She was reportedly entertained at the White House by Harriet Lane, the niece of Pres. James Buchanan, and dined with Jefferson Davis, president of the Confederacy. Following Mirabeau's death, Henrietta continued to manage the plantation using slave labor; she later shifted to stock raising, with up to 200 head of cattle bearing her "H" brand.

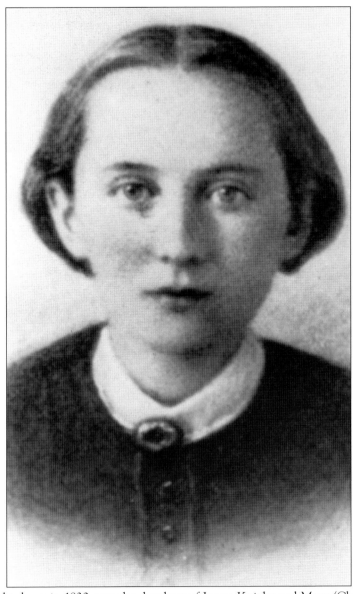

Lucinda Knight, born in 1830, was the daughter of James Knight and Mary (Clark) Beckham. As unmarried men, James Knight and Walter C. White, who had first come to Texas during the Long Expedition, partnered to qualify for a land grant in Stephen F. Austin's colony. As business partners, they operated a store and a trading post and ran a ferry. Wishing to convey property to his daughter, Knight adopted Lucinda as his legal heir using a special act of the Texas legislature. Shortly after Lucinda's 1849 marriage, her half-brother, Thomas Beckham, shot and killed her husband, William Nibbs. Nibbs had threatened to kill Beckham if he did not leave his home, even lending him money to expedite the process. Beckham instead took the money to Houston, purchased a gun, returned to Fort Bend, and shot Nibbs dead while he was on his horse. Lucinda's next marriage, less than three years later, was to a wealthy planter from North Carolina named Durant Franklin Jarman who lived a mere five months. Undeterred by the deaths of two husbands, Lucinda married a third time, to Dan Connor, in 1854. She died in 1857 at age 27, one year after the birth of her daughter Mary (Mollie). James Knight died the following year. (FBCL.)

Walter Moses Burton was born a slave in North Carolina around 1829 and was brought to Fort Bend County by his owner, Thomas Burke Burton, son of North Carolina governor Hutchins Gordon Burton. During Reconstruction, Walter was elected sheriff and tax collector of Fort Bend County (in 1869) and later became a Texas state senator, serving from 1874 to 1875 and from 1876 to 1882. In the state senate, he championed African American education and the bill that led to the establishment of Prairie View A&M University. He filed a lawsuit against a railroad company when his wife, Abie, was evicted from a car based on race. His daughter, Hattie, died following a shoot-out with a former lover. Burton sent a monthly remittance to his former master's indigent widow from the time he was freed until her death in 1878. He died in 1913 and was the first African American buried in Morton Cemetery in Richmond. (15th Legislature; Detail: W.M. Burton; Accession ID: CHA 1995.011; Courtesy State Preservation Board, Austin, TX; 11/12/96, post conservation.)

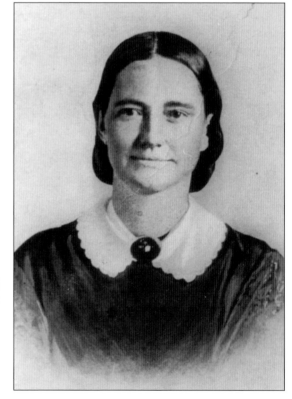

E. Jane Pickens (c. 1827–1860) was the eldest daughter of John Harris and Eleanor (Cooper) Pickens and came to Texas from Kentucky at the age of three. She grew up in the vicinity of Crabb. Her father was one of 60 men to sign a petition for the formation of Fort Bend County. Purportedly, following the defeat of the Mexican army at San Jacinto, a starved and exhausted Mexican soldier, Jose Maria, arrived at the Pickens homestead, was taken in by the family, and lived out the remainder of his life with them. Jane eloped with William Kinchen Davis (page 16) after he returned from the Mier Expedition. When he left in 1842, Jane was 15 years old; thinking he was dead, she became engaged to another suitor. Davis returned and she eloped with him the night before her intended wedding. The couple had five children: Fannie, who died at the age of three; J.H.P. (page 16); Eleanor, who married B.A. Hinson; W.K. Jr., who was killed by a railroad car in 1888; and Archietta, who married W.L. Jones.

These images show Col. William M. Ryon and his wife, Mary Moore Ryon, known as "Aunt Polly." William was born in Kentucky in 1808. He enlisted in the military and participated in the Second Seminole War in Florida, where he became a colonel. He arrived in Texas in 1837 and fought in several campaigns against Indians, and in 1842, he raised a group of volunteers from Fort Bend County to join the Somervell Expedition (page 17), a retaliatory mission for Mexican raids upon Texas earlier that year. When the army was dismissed, Ryon continued with a rogue expedition against the city of Mier, where he was captured by the Mexican army; he escaped at Salado on the march to Mexico City. As one of 176 recaptured, Ryon was subject to a decree that every 10th prisoner should be executed, to be determined by drawing from a jar containing two colors of beans—white and black— with 17 black beans portending death by execution. After he selected a white bean, Ryon's life was spared, but he was imprisoned in Perote prison.

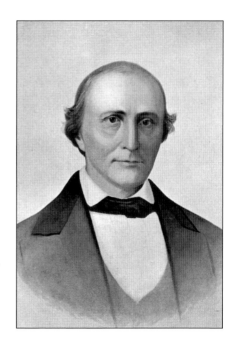

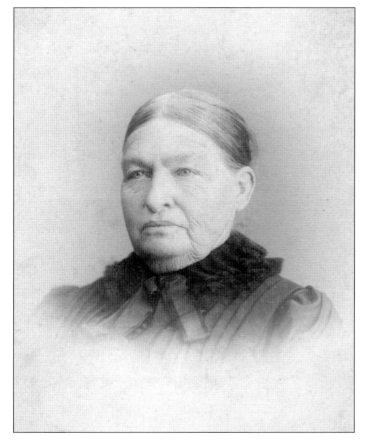

Upon his release, Ryon returned to Texas; in 1845, he married Mary, the oldest daughter of Henry and Nancy (Stiles) Jones, who were among Austin's Old Three Hundred settlers. William died in 1875 at the home of Mier companion William K. Davis, whose son J.H.P. Davis married Ryon's daughter, Susan Elizabeth, that same year. "Polly" died in 1896 and was long remembered for her compassion toward the sick and her community.

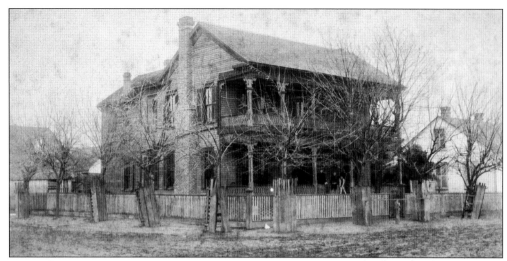

The William Kinchen Davis home faced south on the corner of Fourth and Jackson Streets. Davis (1822–1891) came to Texas with his parents in 1830. He served in a campaign against Native Americans on the Brazos River in 1839, and in 1842 participated in the Somervell Expedition. Captured along with William Ryon as a member of the subsequent Mier Expedition, he drew a white bean (page 15). Following his return to Texas, he married Jane Pickens in 1848, and became a stockman and farmer, moving to Richmond in 1856 to establish a meat market. Referred to as "Captain Davis," he raised a company during the Civil War for local service. His son, John Harris Pickens (J.H.P.) became one of the most influential citizens in Richmond, overseeing large banking and cattle interests.

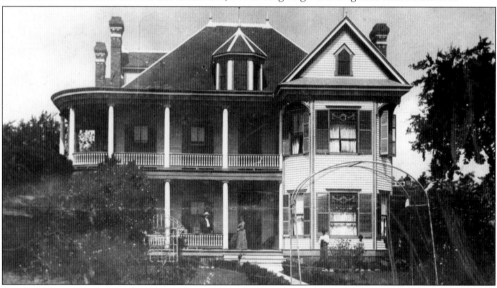

The J.H.P. Davis home was constructed outside of Richmond between 1875 and 1880 for Davis and his first wife, Susan Elizabeth Ryon, at the present site of Oak Bend Medical Center (formerly Polly Ryon Memorial Hospital). The couple had three children: Daisy Belle, who died in infancy; Mamie E., who married A.P. George; and Thomas W. The home was remodeled by Davis and his second wife, Belle Ryon, a cousin of his first wife, in 1892. When the 25-acre site was donated for the hospital by Albert P. and Mamie (Davis) George, the home, where Mamie spent her childhood, was included to be used as housing for nurses. It was used for this purpose until about 1970; in 1977, it was moved to the Arroyo Seco Historical Park (now the George Ranch Historical Park) where it was restored in 1981.

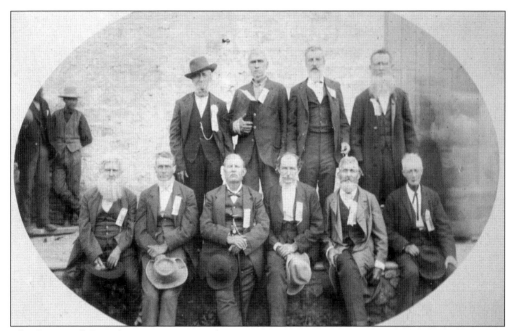

The Somervell Expedition was organized in 1842 by Sam Houston in retaliation against Mexico for several raids earlier that year. Doubting the success of the mission, Somervell ordered the troops to return home. Dissatisfied by the orders to disband, most of the men continued down the Rio Grande and organized the unauthorized Mier Expedition. The troops did not encounter resistance when they entered the town of Mier demanding supplies, and the *alcalde*, or mayor, agreed to meet their demands, so the troops withdrew and waited. In the meantime, Mexican reinforcements arrived at Mier and a bloody battle ensued on Christmas Day 1842, with 200 Texans surrendering, expecting to be treated as prisoners of war. However, they were subject to a decree that every tenth man should be executed. The surviving men were subject to harsh labor and squalid living conditions in the infamous Perote Prison until their release on September 16, 1844. Survivors of the Meir Expedition pose for a group photograph at a reunion. William Ryon and Kinch Davis are in the photograph.

William Kinchen Davis poses in chains at a Meir Expedition reunion to symbolize the treatment he suffered at the hands of the Mexican army.

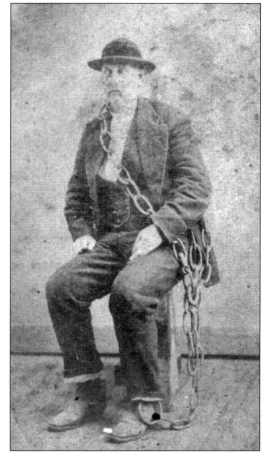

Pictured is the home of Dr. George A. Feris, who came to Texas in 1835. He served as a surgeon during the Texas Revolution and the Civil War. His 1841 marriage to Lavinia Thomason produced nine children. Two sons, Yandell and Keene, were involved in the Jaybird-Woodpecker shoot-out of 1889 (page 37). Lavinia's father, Jesse Thompson, operated a ferry on the Brazos River, which was the site of fighting between the Texan colonists and the Mexican army in 1836. Jesse became engaged in a feud with Thomas H. Borden that led to Thompson's murder. While Thompson family lore painted Jesse as the innocent victim, it appears that he threatened Borden over a long period, and then, in an attempt to kill Borden and a friend, James Cochran, Thompson was shot and killed in 1834.

Phillip Vogel, a German merchant, built this residence in the 1850s. Alexander D. McNabb purchased the home in 1887. In 1889, he married Charlien Gloyd, daughter of temperance crusader Carry A. Nation.

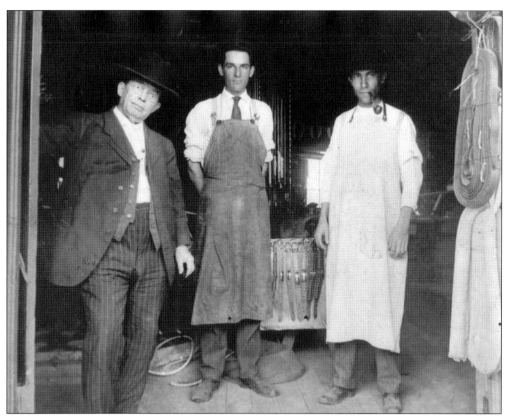

McNabb and Varga provided custom saddles and tack to Richmond citizens. This image shows, from left to right, Alexander McNabb Sr., who married Charlien Gloyd; Paul Pierce, who later opened his own saddle shop in Childress, Texas; and Ludwig Varga, a master saddle-maker who came from a family of Hungarian immigrants who created custom saddles in the San Antonio area.

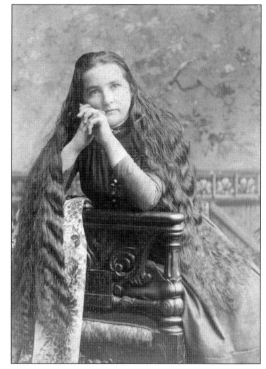

Charlien Gloyd McNabb was the only child of temperance crusader Carry Nation and Dr. Charles Gloyd. Charlien was often ill, and her mother was convinced that it was a result of Charles Gloyd's alcoholism. Carry also worried that Charlien was not a "good Christian" and wrote that she often prayed for some bodily affliction to befall Charlien in hopes that would make her "love and serve the Lord." Charlien married Alexander D. McNabb in 1889 and lived in Richmond until her death in 1929.

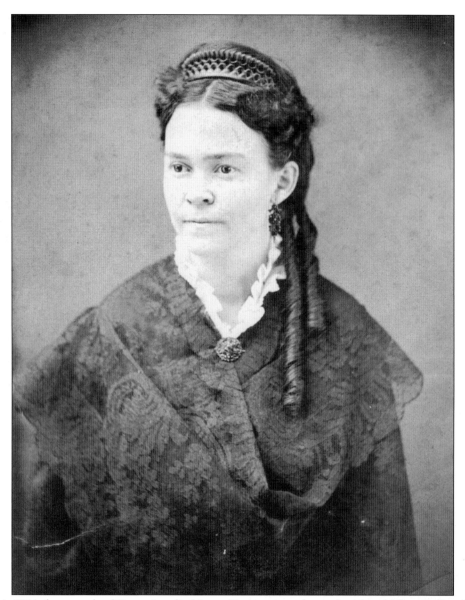

This 1874 photograph of Carry Amelia Moore Nation was taken a few years before she lived in Richmond with her second husband, David Nation. Raised in Kentucky and Missouri, she lived briefly in Texas in the early 1860s. An unhappy marriage to Dr. Charles Gloyd, an alcoholic, produced one child, a daughter named Charlien. Carry fled from her husband only to be forced, by her parents, to return to his home. After Charles died, Carry married attorney David Nation in 1877, and they moved to Texas in 1879. David purchased an interest in the *Richmond Opinion* newspaper in 1883. They purchased a hotel in Richmond in 1884. While in Richmond, Carry had many "mystic" religious experiences, believing God had chosen her to spread his message. Because of her outspoken and sometimes bizarre behavior, Carry was barred from teaching Sunday school at the Methodist and Episcopal churches in Richmond. She began holding Bible study classes in her hotel. After David Nation supported the Woodpeckers in their failed "war" with the Jay Birds (page 37), he and Carry were forced out of Richmond. They moved to Kansas in 1889. (Courtesy of Kansas Historical Society.)

After moving from Richmond to Medicine Lodge, Kansas, Carry Nation began doing charity work to aid the poor. She blamed much of the misery of poverty on alcohol. Her abrasive personality and self-righteousness made her very unpopular with the locals. She was even expelled from a church where her husband was a part-time minister. After founding a local chapter of the Woman's Christian Temperance Union in Medicine Lodge, she began her anti-alcohol campaign in earnest. By 1900, she had adopted the hatchet as her symbol and means of destroying offending saloons. In the 1901 photograph at right, Nation poses with her Bible and hatchet. She sold souvenir hatchets to help defer the cost of her crusade, including hefty fines for her 30-plus arrests for destruction of property. David Nation divorced Carry in 1901 after she publicly denounced his preaching.

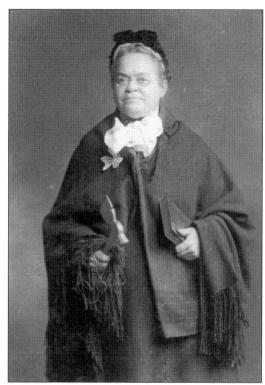

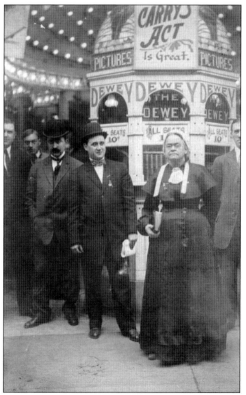

Always in delicate mental health (Carry's mother also suffered from debilitating mental illness), Carry became more erratic as she grew older. In this c. 1904 postcard, Carry poses in front of a display for her vaudeville-type show in which she reenacted smashing up saloons. She died in 1911 after collapsing during a speech.

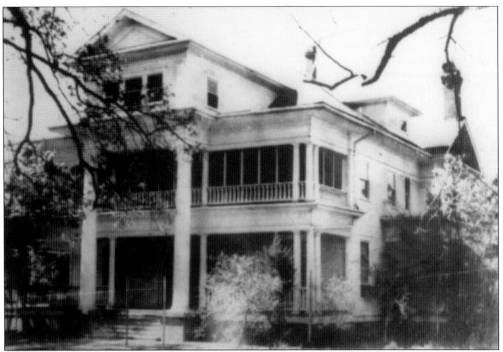

The stately home pictured above was completed in April 1913 for Clement Newton "Clem" Bassett Jr. (1842–1914) and his second wife, Libbie (Mitchell) Bassett (1869–1941). Pictured at left, Bassett was one of the first white children born in Richmond, in 1842, to Clement N. Sr. and Julia (Beale) Bassett. At the outset of the Civil War, Bassett joined the 8th Texas Cavalry, the famed "Terry's Texas Rangers," participating in all of the regiment's major battles. As one of the regiment's most intrepid fighters, he survived injuries to the hand and foot and a shot to the head that perforated his hat, which he kept as a memento. Following his death in 1914, his wife Libbie lived in the home until her death in 1941. Daughter Elizabeth (Bassett) Williams lived in the home, which originally occupied the block between Jackson and Liberty Streets, until it was sold to the county for use as a courthouse annex.

Upon his return from service in the Civil War, Clem Bassett was engaged in the stock business in Richmond until 1870. He then operated a mercantile business until 1885. Bassett and his business partner Sidney J. Winston engaged in large scale farming operations. Bassett also dealt in cattle and real estate. He was a director of the Richmond and Rosenberg Cotton Company, and in 1900 was elected sheriff of Fort Bend County, followed by a four-year term as tax collector.

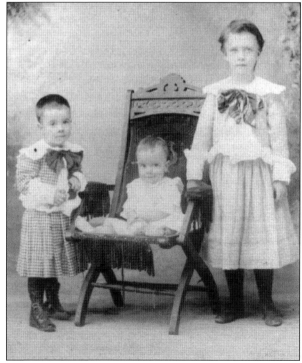

Clem Bassett first married Lida Moore, sister of US Congressman John M. Moore, in 1870, but she died in childbirth and was buried with their baby on their first wedding anniversary. He married Libbie Mitchell in 1885, with whom he had six children: Clement Jr., Winnie, Eleanor, Robert Adair, Sidney Winston, and Gerald, three of whom are pictured here. (FBCL.)

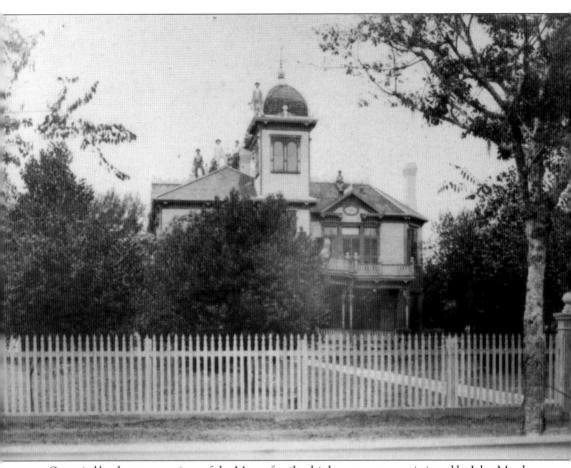

Occupied by three generations of the Moore family, this house was commissioned by John Matthew and Lottie (Dyer) Moore in 1883, the year of their marriage. A prosperous rancher, Moore served in the Texas state legislature (1897–1899) and in the US Congress (1905–1913). The home was built by carpenter Thomas Culshaw, a native of England, as a four-bedroom, two-story High Gothic Victorian mansion with a center tower and cupola. Culshaw built numerous Richmond buildings and residences, including the home of Isaac MacFarlane, whose son Jackson married Culshaw's daughter, Ida. The First Baptist Church of Richmond was founded in the home, meeting here until a permanent place of worship was constructed in 1889. (FBCL.)

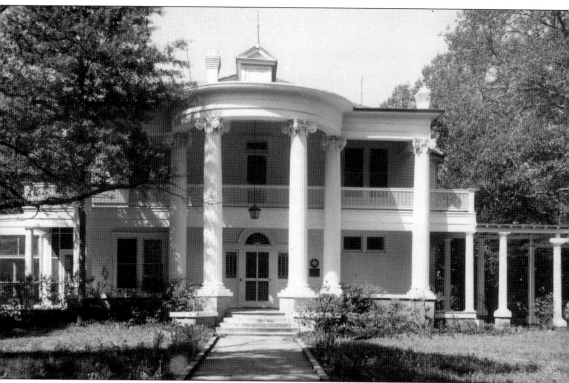

The Moore home is pictured here after it was remodeled in 1905. After his election to Congress in 1905, John M. Moore Sr. commissioned C.H. Page and Brothers of Austin to remodel the 1883 residence in the Classical Revival style as it appears today. The Moores had six children: Max, Raymond E., Ivy, J. Foster Dyer, John M. Jr., and Henrietta "Etta." Dedicated to the preservation of the history and culture of the area, son John M. Moore Jr. donated the 1883 family home and the property on which the Fort Bend Museum was built in 1969, retaining residency until his death in 1975. John M. Moore Jr. served as county judge (1933–1936) and as mayor of Richmond (1937–1942).

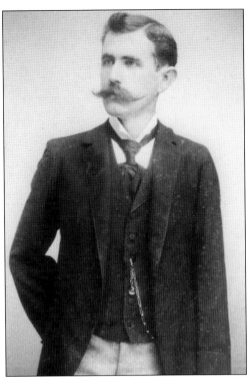

John M. Moore Sr. (1862–1940) was born to Alabama natives Dr. Matthew and Henrietta (Huddleston) Moore. He attended the Agricultural and Mechanical College of Texas (now Texas A&M University), returning to Richmond where he was engaged in merchandising, farming, stock raising, and banking. He became a charter member of the Jay Bird Democratic Association (page 37), served in the Texas legislature (1897–1899), and as a US congressman for the Eighth District of Texas (1905–1913). (FBCL.)

Sen. John M. Moore Sr. (center) stands with two of his ranch hands, Alex Anderson (left) and Frank Bell (right). Moore's wife, Lottie (Dyer) Moore (1865–1924) was the granddaughter of Thomas and Nancy (Spencer) Barnett, both part of Austin's Old Three Hundred colonists. John and Lottie operated the largest ranching operation in the county by 1890.

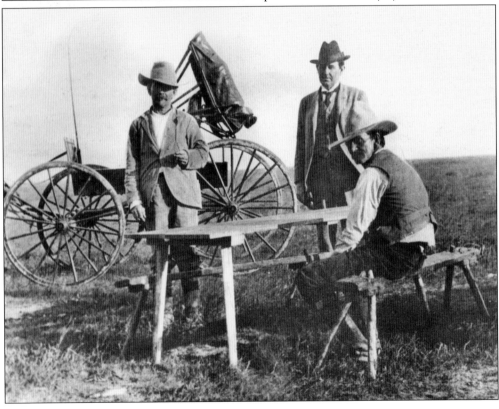

Ivy Mae Moore, granddaughter of John M. Moore Sr. and sister of longtime Richmond mayor Hilmar Moore, is pictured here as a toddler. Ivy married William Chester Morrison of Shelbyville, Indiana, in July 1911; his father was a judge. William died in December 1911 of typhoid fever, leaving Ivy Moore Morrison a 23-year-old widow. She never remarried.

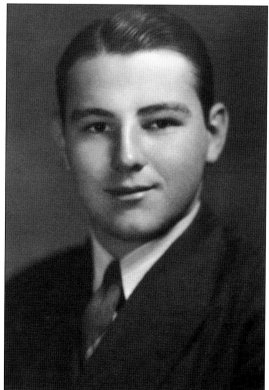

Seen here at age 20, Hilmar G. Moore (1920–2012) would go on to become the longest serving mayor in US history. He was appointed to the office in 1949 and won 32 consecutive elections for a cumulative total of 63 years of service. A son of John M. Jr. and Dorothea (Guenther) Moore, he joined the United States Air Corps in 1942, returning to Fort Bend in 1946 to become a sixth generation cattle rancher. He held many leadership positions in livestock organizations on both local and national levels.

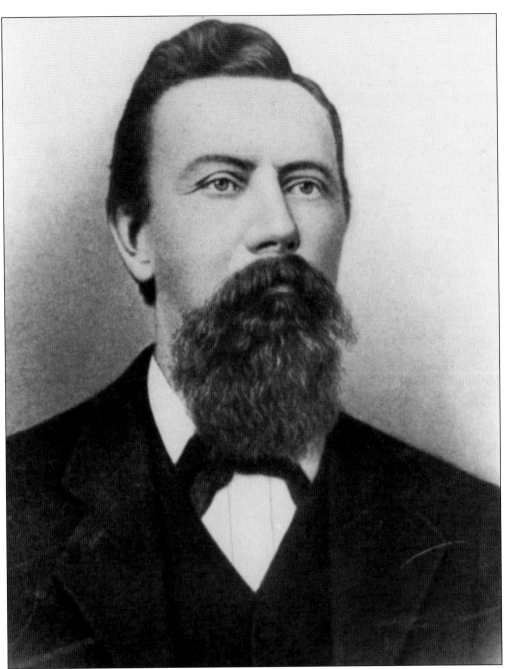

Anton Wessendorff, a native of Prussia, immigrated to Texas in 1854 at the age of 18. In 1858, he married fellow Prussian Johanna Marguerite Janensky. He served in the Confederacy in the 4th Texas Regiment under Gen. John B. Hood and was severely wounded at the Battle of Chickamauga. He started business in Richmond as a cabinetmaker. In 1867, he opened the Wessendorff Lumber Company, later adding funeral and undertaking services. In 1878, he was the founding president of the Fort Bend Agricultural and Horticultural Society, which held the first county fair the same year. The business remained in the family; the undertaking portion was sold to George H. Lewis in 1945.

T.B. Wessendorff (1872–1930), pictured here in 1888, began his career as a messenger boy at the Southern Pacific Depot and later expanded the lumber and undertaking business started by his father Anton to include buggies and wagons as well as the Houston wholesale hardware firm Wessendorff, Nelms, and Co. He served as county treasurer (1902–1906) mayor of Richmond (1909–1922), and as president of the school board and the chamber of commerce. Much revered by the community for his public service and personal philanthropy, the entire town closed for his funeral; according to his obituary, he was laid to rest in Morton Cemetery "beneath a veritable wilderness of flowers."

Cousins Hattie (Jones) Wessendorff (left) and Mamie (Davis) George posed for this studio portrait. Hattie's mother, Archietta (Davis) Jones, and Mamie's father, J.H.P. Davis, were siblings. Hattie married Thomas A. Wessendorff, and Mamie married A.P. George.

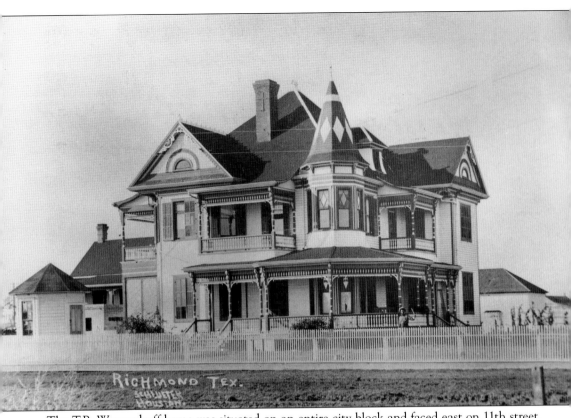

The T.B. Wessendorff home was situated on an entire city block and faced east on 11th street, bounded by Morton, Union, and Jackson Streets. Constructed by T.B. and J.J. Wessendorff between 1900 and 1901 in the Queen Anne style, the home was demolished in 1961 and the First National Bank of Richmond was built in its place.

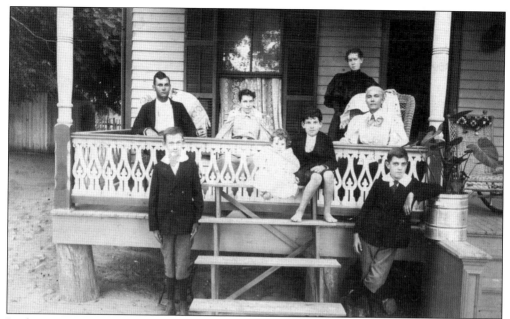

In this c. 1896–1897 photograph, members of the extended Jones-Wessendorff family sit on the front porch of the Archietta (Davis) Jones house, which faced north on the corner of Highway 90A and Second Street in Richmond. From left to right are (on the porch) T.B. Wessendorff, Jennie (Jones) Wessendorff, Hattie Wessendorff (standing), and Archietta (Davis) Jones; (in front of the porch) W.E. Jones, Lizzie Wessendorff, Walter Jones, and Joe Jones.

William Bassett Blakely (left) was the son of Kate Wessendorff and Thomas Calvin Blakely. His cousin Robert Ransom (right) was the son of Mamie Wessendorff (Kate's sister) and Real Ransom.

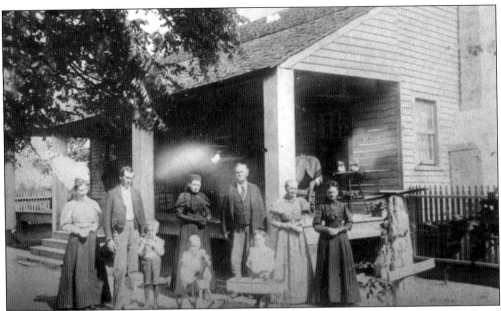

Pictured are members of the Ashley Davis family in 1898. From left to right are Mrs. Annie Davis Quinn (the younger sister of Mary Davis Rich), Dr. John Rich, Max Davis (Annie's son), Mr. and Mrs. Ashley Davis, Miss Bond, and Mary Davis Rich. John and Mary's sons are in front. Ashley Rich Davis sits on a rocking horse and Marshall Howard Rich stands behind a toy wagon. By 1900, Annie Davis Quinn was a 23-year-old widow with a small son, living with her father, J.A. Davis.

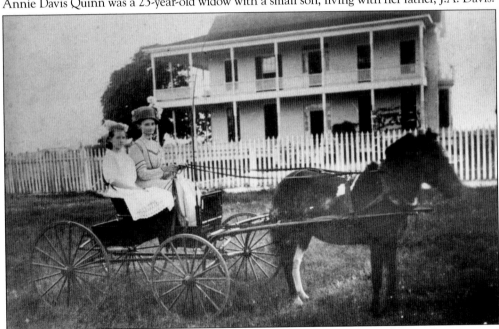

Although the facade of the John Rich home appears coherent, it is actually a medley of several homes from different time periods representing the different families who have lived there. Several generations of the McMahan family lived in the home from 1849 until it was sold in 1882 to Samuel A. Stone, who sold it to Dolph Peareson, sheriff of Fort Bend County, in 1896. After Dr. Rich acquired the home in 1908, he remodeled it.

Built in 1906 by an English shipbuilder, the home of Frank P. and Nell Bell is seen around 1915. Nell stands on the porch with their daughter Frances Louise. The Bells married in 1912. The former Nell Meserve held an M.A. in education and taught in Richmond for 32 years. (FBCL.)

Frank Bell, shown here, first entered public service in 1889 as the public weigher. He later served as postmaster of Richmond and as mayor (1923–1925). His grandfather, George W. Bell, was the first deputy sheriff of Fort Bend County in 1837. Frank held that position from 1926 to 1930, when he was struck and killed by an automobile as he was assisting a disabled motorist. (FBCL.)

Women from several prominent Richmond families pose for this photograph. From left to right are (first row) Hallie Darst Hodges, Mrs. Blakely, Mrs. Freeman, Mrs. Barrett, Archietta (Davis) Jones, Elnora (Davis) Hinson, and Mrs. Dyer; (second row) Mrs. Ware, Emma (Moore) Newell, Mrs. Andrus, and Belle (Ryon) Davis. At far right under the window are Kate (Peareson) Andrus (left) and Fannie (Booth) McFarlane.

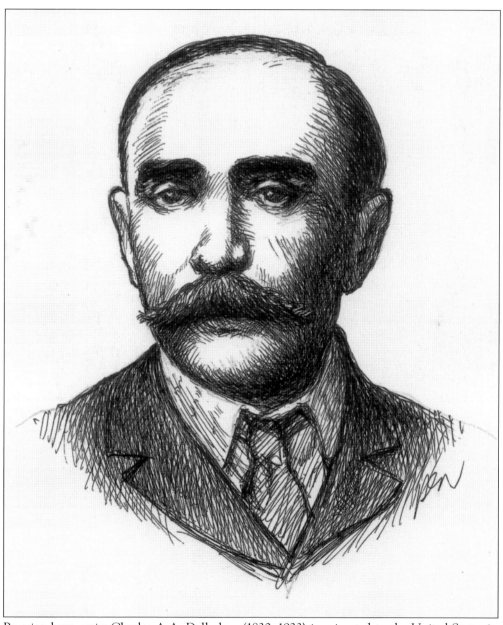

Prussian-born artist Charles A.A. Dellschau (1830–1923) immigrated to the United States in 1850 and received his letters of citizenship in Fort Bend County in 1860. In 1861, he married Antonia Hilt, widow of Pierre Hilt, in Richmond, and worked as a butcher for nearly 20 years before relocating to Houston. Upon retiring around 1899, he began to document the activities of the Sonora Aero Club, a group of flight enthusiasts based in Sonora, California, during the mid-19th century. Dellschau created a scrapbook filled with fanciful illustrations of flying machines. After his books were recovered from a landfill in the 1960s, four of which were purchased by Dominique de Menil, the possibility of proving his stories as fact or fiction garnered much interest and intrigue. Dellschau's works have been displayed by museums across the world. He is buried in Washington Cemetery in Houston. This sketch by Pete Navarro is from an original photograph. (Courtesy of Pete Navarro.)

Arizona Fleming (1884–1976) was born in Richmond, went to segregated schools, and attended Guadalupe College, an African American Baptist institution in Seguin. After working as a bookkeeper and master seamstress, she co-founded the Fort Bend Fraternal Undertaking Company and eventually became the sole proprietor. In 1950, Fleming and Kendleton farmer Willie Melton began a suffrage movement that led to legal action against the Jay Bird Democratic Association, which barred African Americans from a pre-voting candidate election process that determined nominees for local elections, thus disenfranchising minority voters. Fleming was present in January 1953 when the Supreme Court heard the case, *Terry v. Adams*, and upheld the original ruling of the US District Court in Houston in favor of the plaintiffs.

Two

LOCAL GOVERNMENT

On August 16, 1889, a 20-minute gun battle raged in the streets of Richmond after a fissure in the Democratic Party in Fort Bend County in the late 1880s led to the infamous Jay Bird-Woodpecker War. The Woodpeckers sought cooperation with African Americans since they held a majority of votes in the county. The Jay Birds resented this and accused the Woodpeckers of corruption and mismanagement. The conflict reached a boiling point when members from each group engaged in a shoot-out around the Richmond square. Three of the Jay Birds were killed—H.H. Frost, J.M. Shamblin, and L.E. Gibson. The granite Jay Bird Monument, pictured here, commemorates the deaths of these men. The dead Woodpeckers, including Sheriff T.J. Garvey and Jake Blakely, along with innocent bystander Robbie Thomas, a young girl, were not listed on the monument. The monument was unveiled in an elaborate ceremony in 1896 and still stands at the corner of Fourth and Morton Streets on the site of the former courthouse square. (FBCL.)

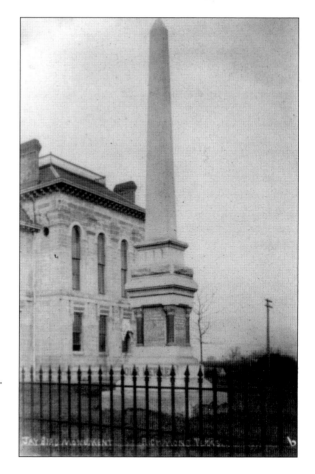

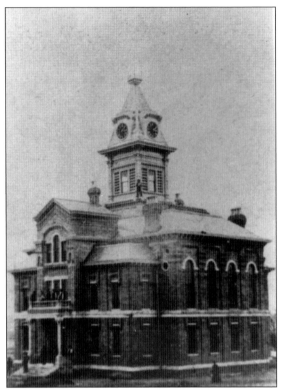

The fourth county courthouse, a two-story brick Victorian structure with a requisite bell tower and clock, was completed in 1888 by B.F. Trester Jr., an Indiana architect who commented, "your magnificent temple of justice . . . is regarded by those who have seen it as one of the best courthouses in the state for the money." The structure was abandoned upon the completion of a new courthouse in 1909 and later occupied by a recreation center and the Rich Hotel (1924) before it was demolished after sustaining damage during a fire.

An unidentified young boy holds a pony near the courthouse. The courthouse, located at the center of the square in Richmond, was the hub of activity in town. (FBCL.)

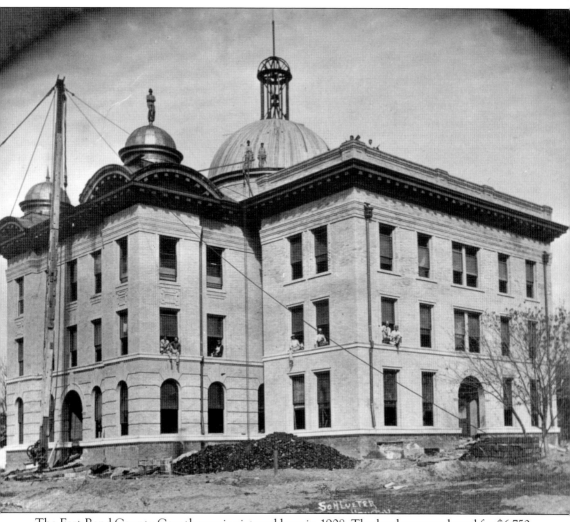

The Fort Bend County Courthouse is pictured here in 1908. The land was purchased for $6,750 and the courthouse was built for a cost of $75,000 and dedicated in January 1909. Note the men on the roof working on the dome and the men leaning out of the second-floor windows. The Classical Revival–style building, more specifically an example of "Texas Renaissance" style, which combined elements of Renaissance Revival, Classical Revival, and Italianate, was designed by C.H. Page of Austin. The first floor consisted of offices and vaults, while the district courtroom was on the second floor. The copper-domed ceiling is topped with a statue of Lady Justice.

This c. 1925 image shows Harris Edlow Mitchell standing in front of the Jay Bird Monument. Mitchell, who is in his late 50s in this photograph, was married to Mary White Mitchell, and his sister, Libbie, was the second wife of Clem Bassett.

An unidentified man poses in front of the Jay Bird Monument. The courthouse is visible in the background at right.

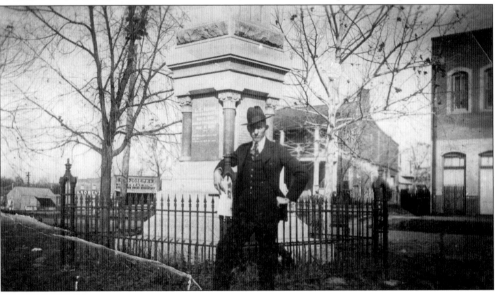

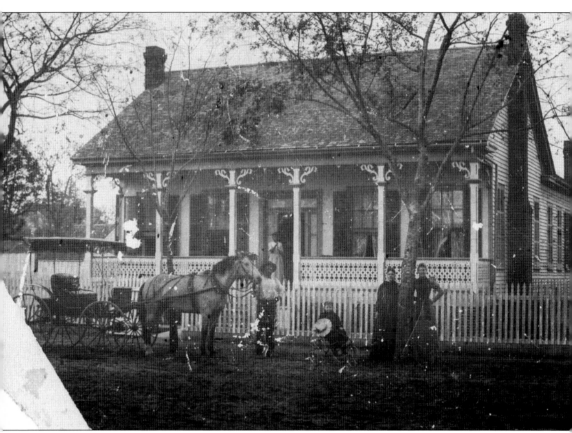

The Thomas W. Jones home in Richmond was likely built in 1854 by Lewis Kurtz who then sold it to Pertima (Casner) Fitze, wife of C. Gustave Fitze, a music instructor at the Richmond Male and Female Academy. The Fitze heirs sold the home to T.J. Garvey, Fort Bend County sheriff and prominent Woodpecker, who left the home during the political turmoil of 1888 and 1889 and sold it to Dr. John M. Weston, regimental surgeon in the Terry's Texas Rangers regiment during the Civil War and Woodpecker candidate for county judge. After the 1889 shoot-out in which the Jay Birds assumed control of county politics, many Woodpeckers left town, and the home was sold to cattleman Thomas W. Jones and his new wife, Nannie (Jones). After the premature death of Thomas, Nannie returned to Kentucky with their daughter, Eliza, to be near family. The home was sold to Dr. J.C. Johnson in 1899 and remained in his family until it was relocated to the Houston estate of Mary Frances Couper in 1974.

Sheriff Miner Lafayette Woolley Sr. lived in the jail from the time he was a deputy sheriff, around 1905. The children on the steps are W.P. "Willie" and Miner Lafayette Jr.

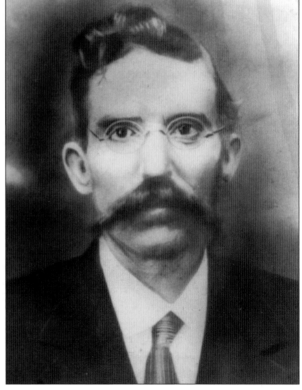

Miner Lafayette (M.L.) Woolley was born in 1866 in Lee County, Texas. His father came to Texas in 1834 and served in the Confederate military during the Civil War. M.L. married Rebecca Wilson in 1886, and they had five children, three of whom outlived their father— Willie, Bertha, and Lorena. After Rebecca's death in 1896, Woolley married Jennie Lou Bryan, and they had four daughters—Oma, Violet, Norma, and Zora, and three sons—Miner Lafayette Jr., Luther Dee, and Truman Bryan. Woolley served four terms as the elected sheriff of Fort Bend County. He died in 1939 at age 73.

In this 1913 photograph, three of Miner Lafayette (M.L.) Woolley's children from his first marriage (to Rebecca Wilson) stand in front of the Richmond jail—from left to right are Bertha, W.P. "Willie," and Lorena.

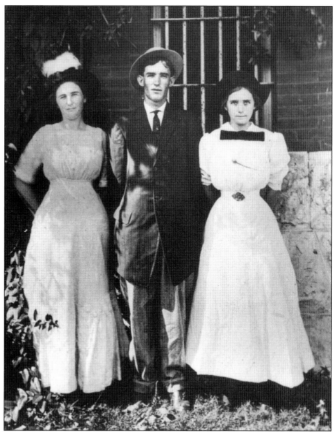

M.L. Woolley's children pose on an automobile in 1920. They are, from left to right, (first row) his sons Miner Jr., Luther, and Truman; (second row) daughters Oma, Violet, Norma, and Zora. (FBCL.)

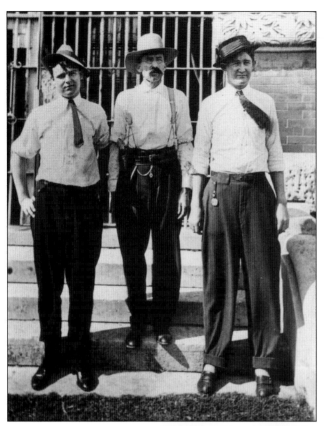

In this 1911 image, Sheriff Miner Lafayette Woolley (center) poses with deputy "Dink" Hagan (right) and a man identified as H.M. Shannon.

Shown in 1913 at the sheriff's office in the courthouse are Mr. Ogilvy (seated at the desk), Deputy H.M. Shannon (third from the left), and Sheriff M.L. Woolley (far right). H.M. Shannon acquired the *Texas Coaster* newspaper, which became the *Herald-Coaster*, and then the *Fort Bend Herald*. In 1919, he patented an improved emergency tire. Shannon was a celebrated local writer, known for his column "Pensive Thoughts" and for his poetry.

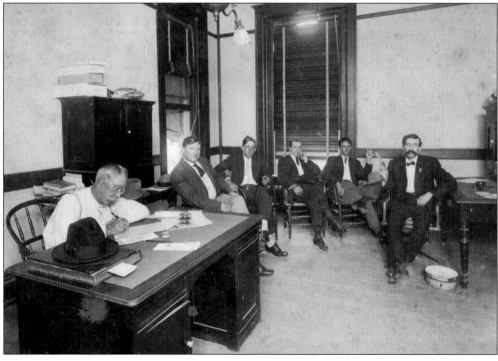

Allen Wheat (right), born in Richmond, served in the "Loyalty Ranger Force" in Liberty County. The Loyalty Ranger Force was created by an act of the 35th Texas legislature. The group reported to the adjutant general about possible revolutionary activity in areas along the Texas-Mexico border. Wheat volunteered in 1918 at the age of 37. In the document, where it listed compensation for Rangers, Wheat crossed out the pay and wrote in that he would serve without pay. Wheat previously worked in the Fort Bend sheriff's department. The man at left is an unidentified Fort Bend deputy. (FBCL.)

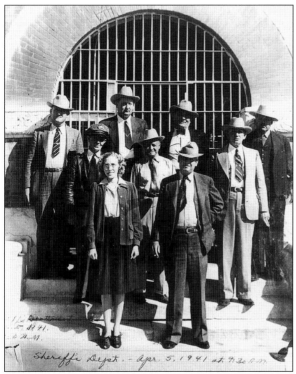

The members of the 1941 Sheriff's department pose on the steps of the county jail. In the front row at left is Zora Dell Woolley, the youngest daughter of former sheriff Miner Lafayette Woolley, who served as the "office deputy." Next to her is sheriff Rusk Roane. The rest of the people in the photograph are, from left to right, (second row) Rue Lincecum (county patrolman), Charles "Smitty" Smith (cook and jailor), and Ed Battle (deputy sheriff at Stafford); (third row) deputies Fred Zwahr, "Slim" Barta, and Paul Wenzel. Zora, who died at age 89, was the first female deputy sheriff in Fort Bend County when she served under her father. She worked for the county for 36 years. She also served under Sheriff R.L. "Tiny" Gaston (page 46).

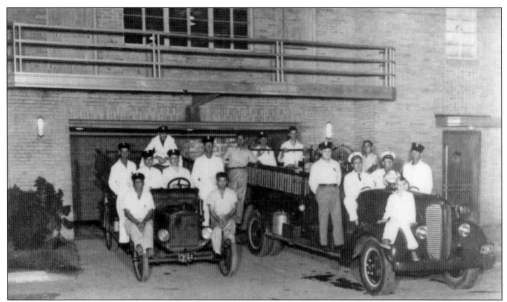

In this 1947 image, the Richmond volunteer firefighters pose with two of their fire and rescue vehicles in front of the fire station. The truck on the left is a vintage 1925 Model T Ford fire truck, the first piece of motorized equipment purchased by the department. Lee Richies sits in the driver's seat. At center right, wearing a dark cap and standing on the running board of a 1937 Dodge truck, is Bennie C. Oberhoff, who served as a volunteer firefighter from 1941 until his death in 1982. To Oberhoff's left, seated in the truck, is Earl O. Bender and next to Bender in the driver's seat is Milford Gless. Bender served from 1924 to 1976, and was chief from 1943 to 1956. In 1947, Bender was chosen as the Texas Firefighter of the Year. Gless served from 1936 to 1983. Standing next to Gless (far right) is Anton Donlik. (FBCL.)

The Jay Bird Monument is visible in the background at left in this c. 1950 photograph. Officer R.L. "Tiny" Gaston of the Richmond Police Department is at left, and the officer next to him is unidentified. Gaston later served as the Fort Bend County sheriff.

Three

BUSINESS AND COMMERCE

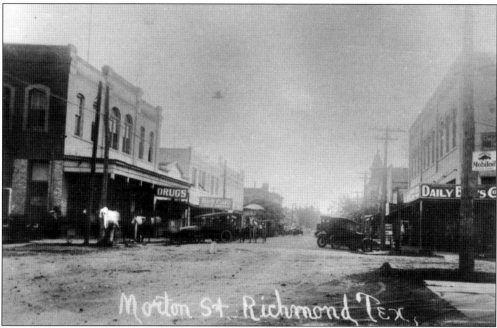

This photograph of the corner of Morton and Fourth Streets was taken in the 1910s. The building in the left foreground was built in 1900 by Mattie T. (Brown) Parnell, the widow of Sheriff C.W. Parnell, as an investment property shortly after his death in 1899. The lots were once owned by Peter Martin, a freed slave, and also housed a portrait studio before Mattie Parnell acquired the property. In 1901, she leased the second floor to the Improved Order of Red Men, Shawnee Tribe No. 50 (page 107) for $216 per year. Dr. John Mark O'Farrell purchased part of the building in 1913, and leased a room to the United States Post Office through 1950. In 1950, Rosa L. O'Farrell, the widow of Dr. O'Farrell, sold her portion to pharmacist Erwin Gray (E.G.) Field. The building is currently home to Sandy McGee's Restaurant.

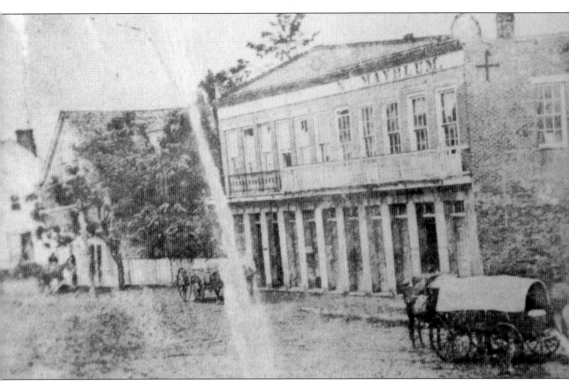

In the oldest known photograph of Richmond's business district, the N. Mayblum store is seen on the right. The firm of Blum & Mayblum, consisting of Alexander Blum and Nathan Mayblum, operated from 1855 to 1859, at which time Mayblum continued the business independently as a staple and fancy dry goods store. Mayblum also accepted consignments of country produce, earning a commission for selling the produce locally or in the Galveston, New Orleans, and Northern markets. In 1859, dentist Andrew Dunlap Nevius located his business on the second story of the Mayblum building, offering "teeth of the latest and best manufacture." A native of New York state, Nevius left Texas for Mexico at the outset of the Civil War, not wanting to enter the Confederate army. The Mayblum building, which was located on the north side of Morton Street, was referred to as the "Old Stand," and operated throughout the 1870s. Mayblum, having great confidence in the agricultural wealth of the county, extended credit to many farmers, but several crop failures led to his financial ruin. He died in 1883, reportedly working himself to death in an attempt to recoup his losses. He is buried in Beth Israel Cemetery in Houston next to his wife, Sophia.

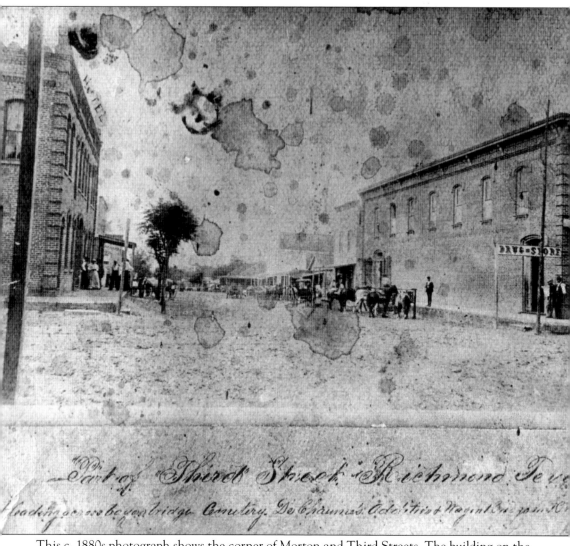

This c. 1880s photograph shows the corner of Morton and Third Streets. The building on the left was built as the Exchange Hotel in 1885 and was divided into two structures, the Lindell Hotel, later renamed the National Hotel (not to be confused with David and Carry Nation's hotel by the same name, see page 20) and the First National Bank of Richmond, started by J.R. Farmer in 1914. The bank operated in the section of the original building on the corner of Morton and Third Streets, and today is occupied by the Italian Maid Café. The building on the right has housed a dry goods store, drug store, department store (Robinowitz Brothers), several restaurants (most notably the Barker House Restaurant), and recently, an art gallery. The handwritten note on the photograph indicates that it was taken in the direction of DeChaumes addition. In the early years of Richmond's growth, the land surrounding the city was platted and sold by enterprising developers, one being Michael DeChaumes. DeChaumes, a French-born architect who immigrated to Houston in 1837, never lived in Richmond. In 1854, while living in Austin to oversee the construction of the Texas State Capitol, he purchased the remainder of the land originally granted to Morton not included as part of the original town site. He divided and sold the land, which included the cemetery where Morton had buried Robert Gillespie in 1825 (page 106).

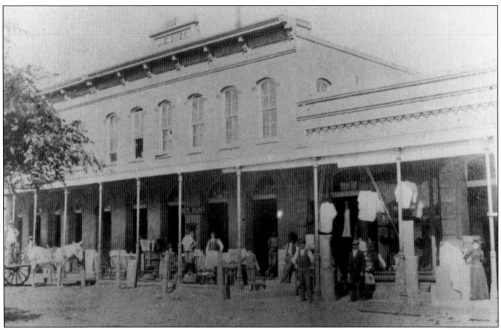

The J E. Dyer Dry Goods and Clothing Store was built in 1885 on Morton Street near the corner of Third Street by John Eli Dyer, the son of Judge C.C. and Sarah (Stafford) Dyer, who was a prominent stock raiser, merchant, and banker. He served as county treasurer (1852–1859) and served in Waul's Texas Legion during the Civil War. (FBCL.)

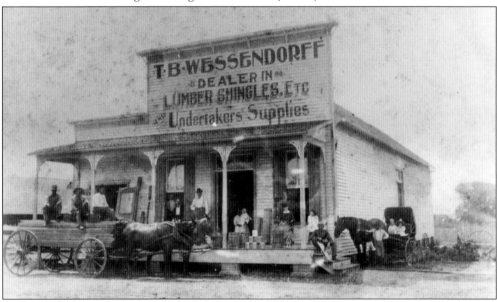

The T.B. Wessendorff Lumber Company and Undertakers' Supplies is pictured here around 1895. At left, three men sit atop a wagonload of lumber. T.B. Wessendorff is in a white shirt to the left of the doorway. His wife, Jennie, is in front of the window. At right is a buggy with two children in it, one of whom is Wessendorff's daughter Jennetta. At far right on the porch, dressed in white, is another daughter, Lizzie. The youngest daughter, Marguerite, is likely the infant being held by the African American woman in the doorway.

Shown here is the Veranda Hotel around 1899 at the corner of Morton and Fourth Streets. It was previously named the National Hotel when it was owned by Carrie and David Nation (page 20), who purchased the property from Adam Schmicker. The Bassett & Blakely storehouse was moved to the site and remodeled to become the hotel, which opened in August 1885. It was later replaced by a large two-story brick building that housed the Levy-Daily Dry Good Store (page 56.)

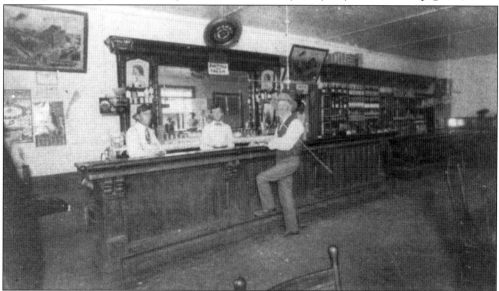

The Three Brothers Saloon, operated by Jenks S. (not pictured), James Joshua "Josh" (left), and Lewis S. Adams (center), was located on Calhoun Street. The wives of the brothers, being devout Baptists, convinced them to quit the saloon business. James became a paint and wallpaper contractor; Jenks was a farmer, rancher, and city commissioner; and Lewis ran a country store. William N. Worthington (right, with cane) was a master carpenter and bridge builder for the Southern Pacific Railroad, and later owned a drug store in Rosenberg. Worthington was the uncle of Virginia "Jennie" (Ryon), the wife of James Adams.

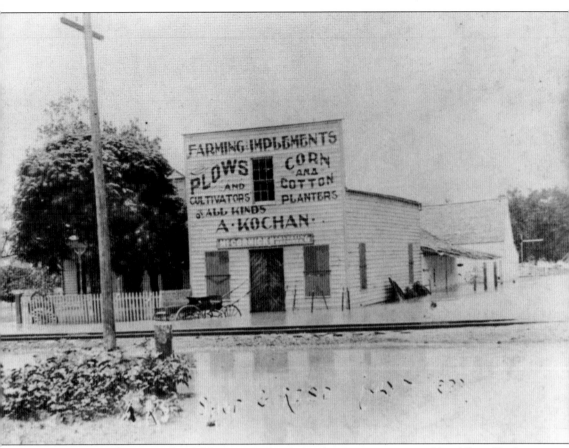

Shown during the 1899 flood (chapter 4), the A. Kochan store was started by Albert Kochan (1867–1948), who operated a blacksmithing and farming implements business in Richmond beginning in 1889. Located on the corner of Calhoun (formerly Railroad) and Fourth Streets, a 1912 advertisement claimed Kochan was an "expert on faulted, gaited and lame horses."

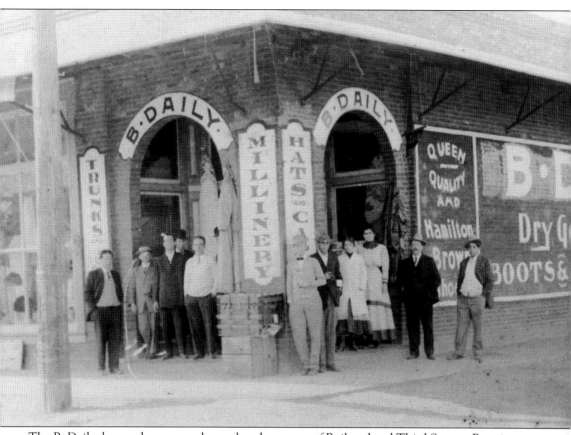

The B. Daily dry goods store was located at the corner of Railroad and Third Streets. Proprietor Benjamin (Delatitsky) Daily, a native of Vishnevo, Russia, immigrated to the United States in 1886. Several branches of the related Russian Jewish families of Delatitsky (Daily) and Robinowitz immigrated to Fort Bend and Harris Counties and were engaged in the mercantile business. The early Jewish business community of Richmond also saw the start of future chain giants Weingarten's, Oshman's Sporting Goods, and Weiner's.

The image above shows the exterior of the Jones and Hinson Grocery Store. Joe A. Jones and Walter H. Hinson started the firm around 1900; it operated until Jones's death in 1923. Walter Harris Hinson (1880–1936) served as the first fire chief of Richmond in 1924. Below is an interior view of the store. Pictured are, from left to right, R.E.L. Wessendorff, Jones, Ike Bryan, and Hinson. (Both, FBCL.)

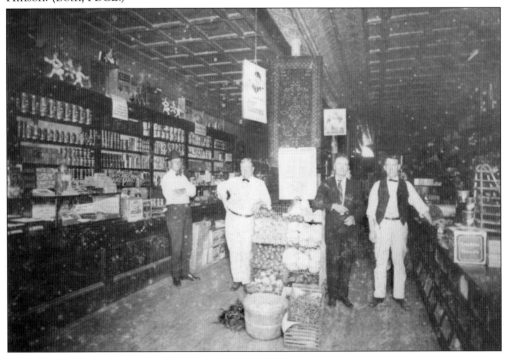

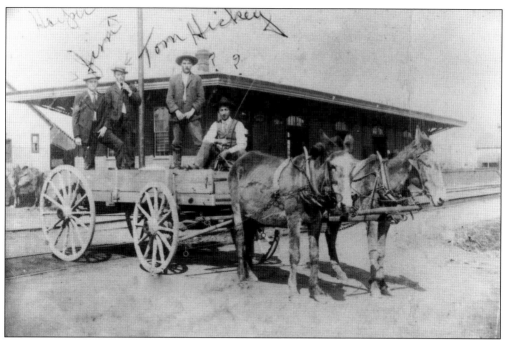

Jim Harper and Tom Hickey stand in a wagon at the railroad depot with two unidentified men. Jim Harper was an agent for the Southern Pacific Railroad in 1910 at age 22. His sister, Tillie, worked as a telephone operator for the Southwest Telephone and Telegraph Company (pages 61 and 121). In 1910, they both lived with their uncle, Henry Reading. (FBCL.)

The Adams Brothers store is pictured here around 1890. (FBCL.)

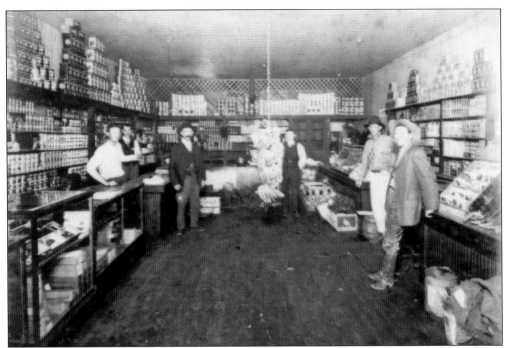

This photograph shows the interior of Levy's Grocery Store. Nathan Levy was a Russian Jew by birth and arrived in the United States in 1906 along with his wife, the former Sophia Daily, whose family were also merchants in Richmond. (FBCL.)

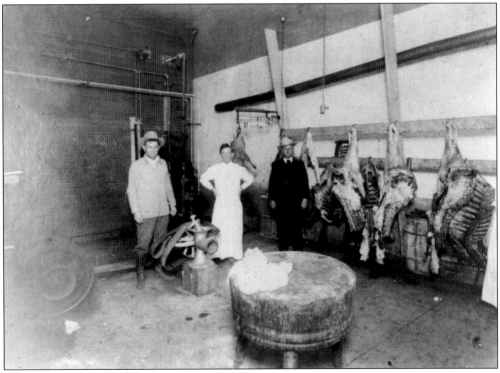

This is a c. 1900 view of the interior of a butcher shop on Calhoun Street. (FBCL.)

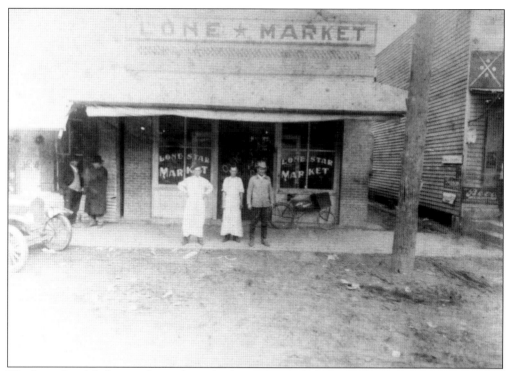

The Lone Star Market was located on Third Street in Richmond. This c. 1910 photograph shows Harris Mitchell on the left and Isaac Bryan on the right. Isaac Richard "Ike" Bryan and O.H. Daniels were the proprietors of the store. (FBCL.)

Children gathered at the Rosen Dry Goods Store to receive free Easter presents. Peter Rosen, the owner of the store, was born in Germany and came to Texas as a child. He died in 1909 at age 40 and is buried in the Beth Yeshurun Cemetery in Houston. Although there was a small Jewish community in Richmond, Rosen may have sponsored the Easter giveaway to demonstrate that he welcomed all customers at his store. (FBCL.)

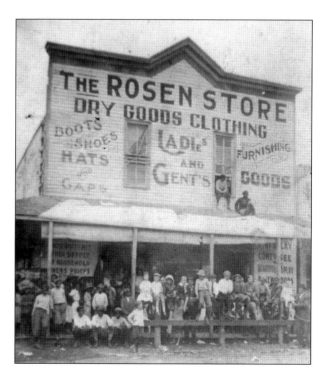

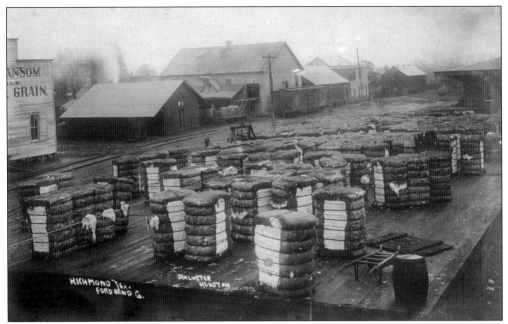

In this 1909 postcard, cotton bales await loading at the railroad depot. The Ransom Store is visible at left.

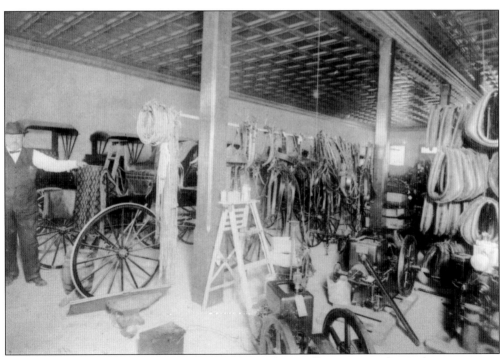

This image shows the inside of a saddle shop located on Calhoun Street. (FBCL.)

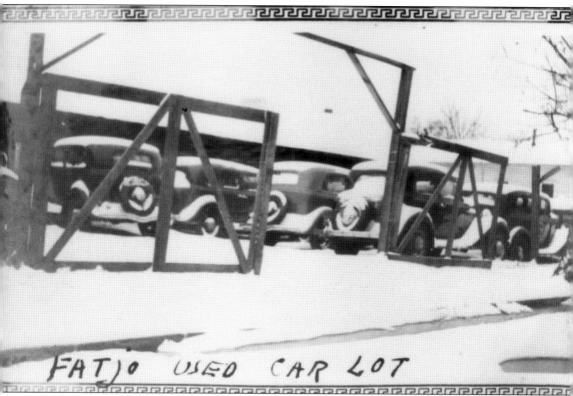

In this 1940s image, a car lot owned by Thomas J. Fatjo Jr. is covered by a rare blanket of snow. Thomas married the former Doris Cooper. His father, Thomas Sr., joined the family printing business of his father-in-law, William H. Coyle, of Houston. The Fatjo family pursued a variety of business interests in Richmond and Houston. (FBCL.)

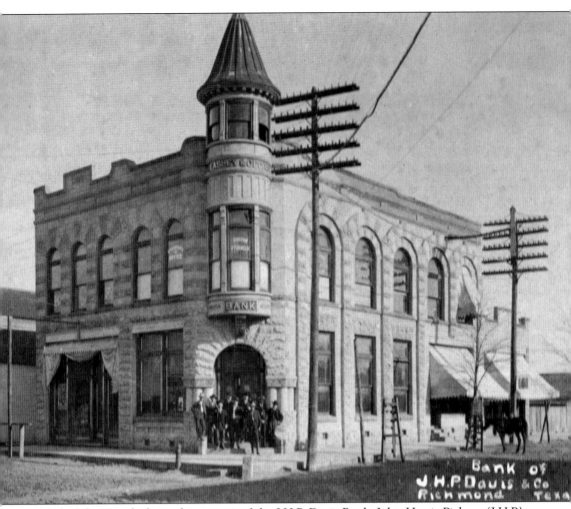

This photograph shows the exterior of the J.H.P. Davis Bank. John Harris Pickens (J.H.P.) was called "Judge" Davis out of respect, not having officially served in that capacity, although he did serve as a county commissioner for seven years. One of the richest men in Fort Bend County, Davis oversaw banking and cattle interests, the Richmond Cotton Company, the Richmond Electric Company, and the Rosenberg Gin Company. Built in the Victorian Romanesque Revival Style at the corner of Third and Morton Streets, the bank building also held county offices and Richmond's first telephone exchange. The building was demolished in the 1950s.

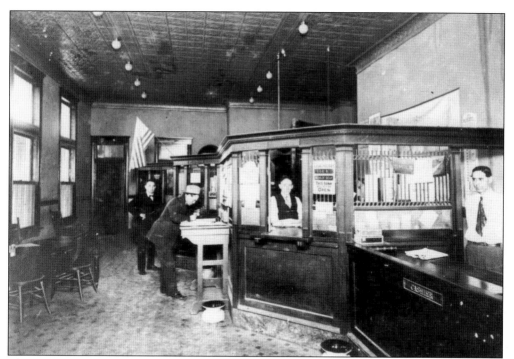

This is an interior view of the J.H.P. Davis Bank. A teller is leaning on the counter behind the window at center, and a customer appears to be filling out some paperwork to the left. (FBCL.)

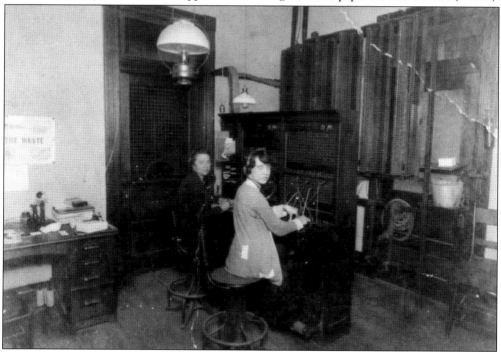

The telephone switchboard was located upstairs at the J.H.P. Bank. The operator in the foreground of this 1920s photograph is Tillie Harper. Harper worked as a telephone operator in the 1930s as well, and was the chief operator by 1940. (FBCL.)

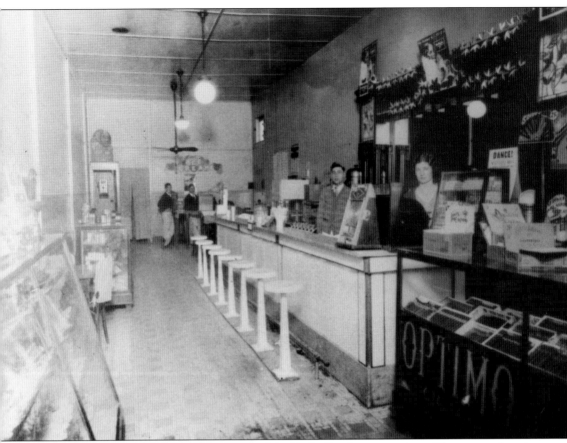

This 1926 photograph shows the interior of the Eagle Confectionery store. The store, a favorite among local children, sold a variety of candy and other sweets. (FBCL.)

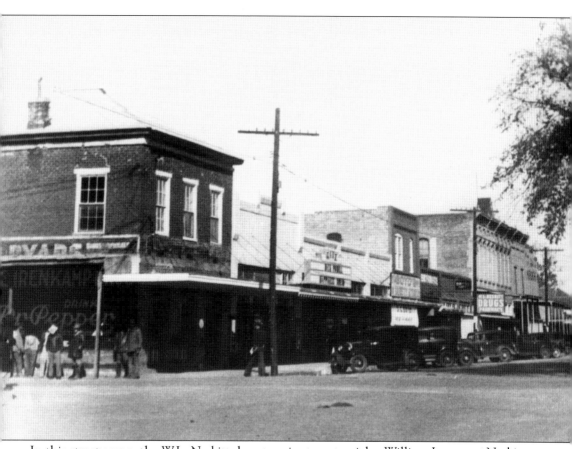

In this street scene, the W.L. Nesbitt drugstore is at center-right. William Lawrence Nesbitt operated this drugstore in Richmond and later moved to Columbus, Texas, where he opened another drugstore. (FBCL.)

This is a view of the interior of the Robinowitz Store. Owner Joe Robinowitz was born in Russia in 1889 and came to the United States at an early age. The Robinowitz Brothers firm dealt extensively in South Texas in the mercantile, cattle, and cotton business. Joe and his wife, Rosa, operated the store. (FBCL.)

This is a photograph of the Robinowitz family: Joe Robinowitz; his wife, Rosa; and their daughters, May and Beverly, and son, Milton. Joe's brother Cecil lived in nearby Rosenberg. Cecil and his wife, Raye, had two daughters, Alieene and Miriam, and a son, Herbert. Alieene pledged the same sorority at the University of Texas as her cousin May. (FBCL.)

In this c. 1930 photograph are, from left to right, May Tee Robinowitz with her friends "Cutie" Ransom, Frances Dyer, and Maree Shannon during the time when Robinowitz and Shannon were in school at the University of Texas in Austin. The four friends were known as "the big four" in their high school days in Richmond. Robinowitz pledged with Phi Sigma Sigma, a sorority that welcomed Jewish members, and Shannon pledged with Delta Delta Delta. (FBCL.)

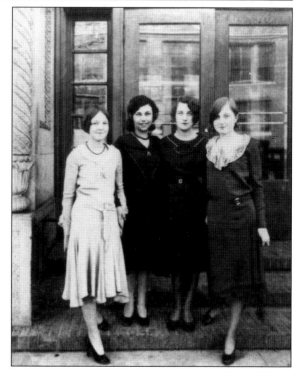

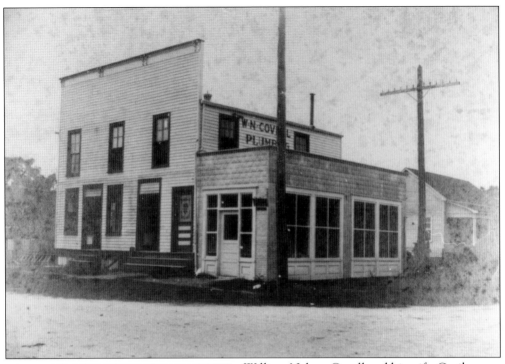

William Nelson Covell and his wife, Cecile, moved to Richmond in 1913, one year after they married in Louisiana. Covell's plumbing and electrical contracting business is shown here. A prominent civic leader, he was a charter member of the Richmond Rotary Club; the Rosenberg Council, Knights of Columbus; and Sacred Heart Catholic Church. He was a director of the Fort Bend National Bank of Richmond, serving as chairman of the board, and a trustee of the Richmond Independent School District. (FBCL.)

The Covell children—likely Doris and William—play with the family dog near their family's business. (FBCL.)

Four

THE BRAZOS RIVER
IN RICHMOND

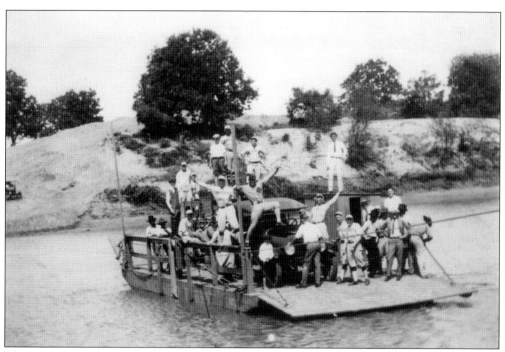

The Brazos River was key to the prosperity of Richmond. Whenever there was a problem with one of several versions of the Brazos River Bridge, the city reverted to using a ferry crossing. In this 1922 photograph, a group of baseball players enjoy a ride across the Brazos River. The rope system used to move the ferry is visible, as is the ferryman (using a pole at far right). The earliest ferry crossing the Brazos was the Thompson Ferry, operated by Jesse Thompson in 1828 and located on land owned by James Knight (page 13). Thompson was killed in a dispute with Thomas Borden in 1834 (page 18), and Thompson Ferry was the site of a battle between the Mexican army and Texas rebels in April 1836. (FBCL.)

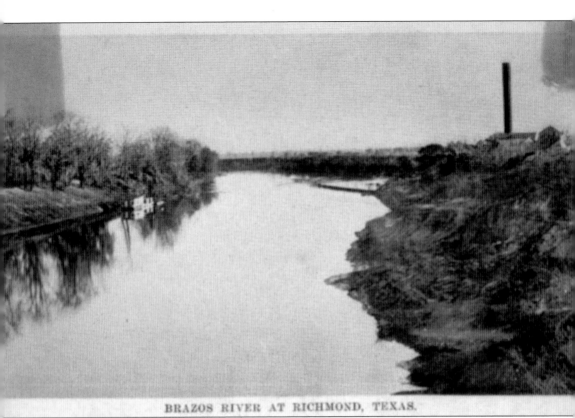

BRAZOS RIVER AT RICHMOND, TEXAS.

The 840-mile-long Brazos River—the longest river in Texas—was critical to the development of Richmond. In the early years of the city, farmers relied on ferries to carry products across the river. The first railroad to reach the Richmond area stopped at the east bank of the Brazos in 1855. A movable bridge, which rested just six feet above the water line, was a temporary solution. This bridge was maneuvered out of the way when boats needed to pass and swung back into place when a train had to cross. In 1887, Richmond acquired a collapsed bridge from Waller County and rebuilt it over the Brazos.

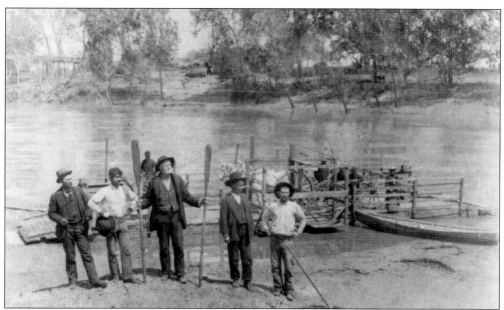

In 1893, a herd of more than 300 cattle caused the middle span of the 1887 bridge to collapse; the city began construction on the Brazos River Bridge in 1894. The cattle belonged to William Nash and were being moved by several cowhands. As the bridge collapsed, men, horses, and cattle fell into the Brazos River. Tragically, two men, Charles Bailey and Sam Johnson, died when they were crushed by horses and falling debris. Some of the cattle managed to swim out of the river only to die from injuries they sustained in the fall. The wooden trestle Brazos River Bridge was built in 1894. In the 1894 image above, taken at the start of construction, several men stand at the ferry. A man in the front center holds oars, while a pair of white horses and a buggy are on the ferry. Below, a group of workers pose in front of one of the wooden trestles constructed for the bridge. Once completed, this new bridge had three trestles and reached Commerce Street in Richmond.

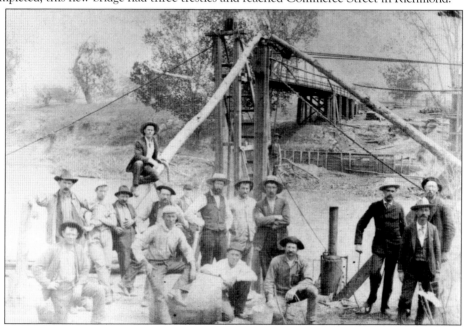

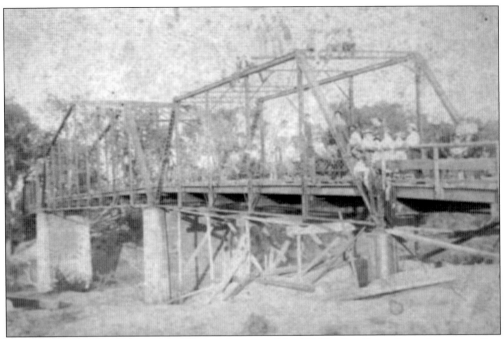

This photograph shows the opening day celebration of the 1894 bridge. Several people are standing on the wooden bridge.

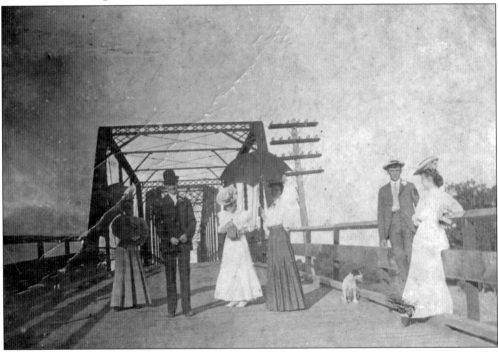

In this picture of the 1894 bridge opening celebration, the couple at right (leaning against the rail) consists of J.J. and Jennie Adams. Second from left is R.J. "Buck" Flanagan, who was 14. As an adult, Flanagan served as the warden of Imperial Prison Farm (later the Central Unit) in nearby Sugar Land into the 1940s.

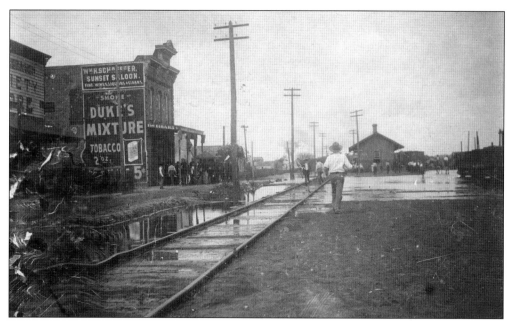

In 1899, after a period of torrential rains, the Brazos River overran its banks, flooding Richmond and many other towns and villages. The Southern Pacific Railroad depot is visible in the center background. This picture was taken during the early stages of the 1899 flood. The water later extended beyond the William H. Schaffer Sunset Saloon, visible at left with a large crowd gathered out front.

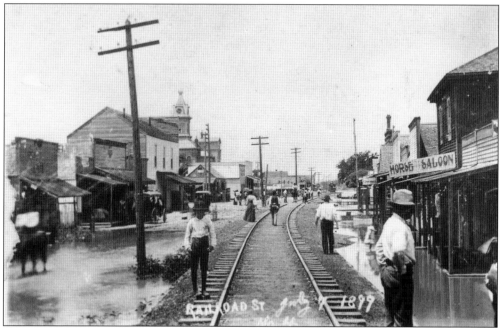

This image shows Calhoun Street—or Railroad Street, as it was often called—with the railroad depot in the background. Several people are walking along the raised railbed to avoid the water that blocks businesses along the road. The clock tower of the courthouse is visible at left center. The Morse Saloon, at right, has water up to the front porch.

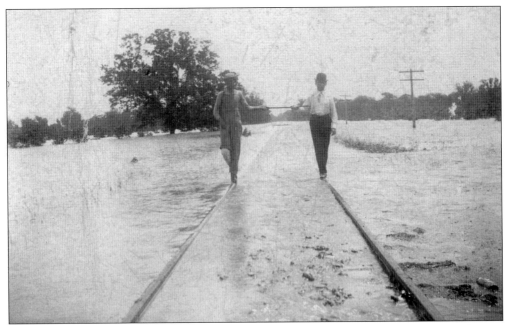

Two unidentified young men walk along the flooded railroad tracks while holding a stick between them for balance. This photograph was taken east of the Brazos River Bridge when the floodwaters first broke over the tracks.

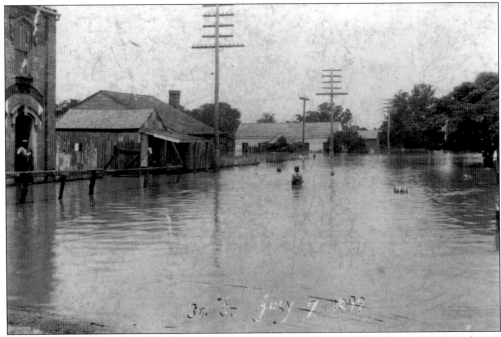

This July 7, 1899, photograph of a flooded Third Street was taken from the Railroad Bridge. A young boy stands hip-deep in water in the center of the street. Two men's heads are visible near him, although they appear to be crouched down for dramatic effect. A barrel floats on the right, and a man looks on from a doorway on the left. In the left background, a home is submerged up to the windowsills.

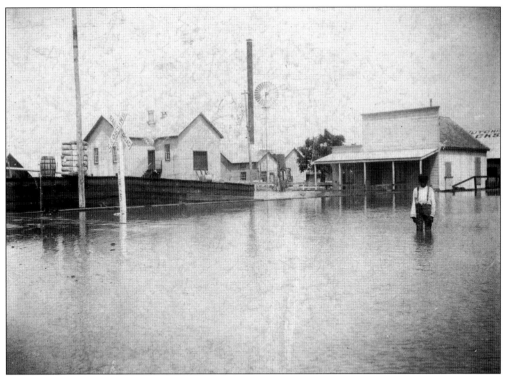

Posing in water to his knees, this young boy is standing near the electric light plant, at center, and the cotton platform at left. A large bale of cotton sits next to a barrel at far left.

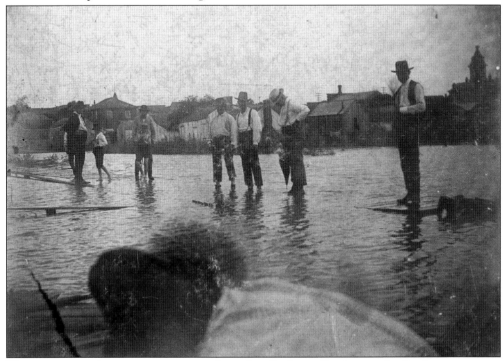

These townspeople are posing on a wooden sidewalk that is floating on the floodwaters.

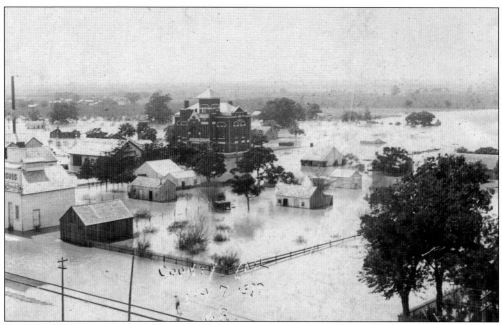

Both of these photographs were taken from the top of the courthouse. In the image above, the Fort Bend County Jail is the dark building at the center surrounded by floodwaters. Below, the Brazos River Bridge is in the background at left, and the railroad bridge is at right. The businesses on one side of the street are partially submerged, while those on the other side are not. The stores on the left side are, from foreground to background, the Austin's Exchange Saloon, Brady Brothers Bakery and Grocery, and F.L. Barnes Restaurant. Baker and Hirsch Grocery is visible at center. At center right, the I. Ditch Dry Goods and Clothing store is visible. Note the buildings in the left background—between the city center and the Brazos River Bridge—that are submerged up to their roofs.

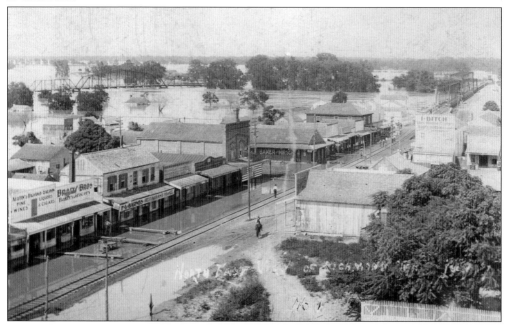

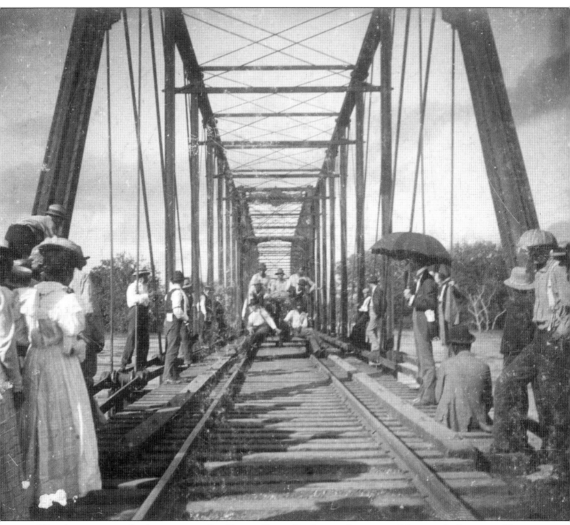

Flood victims made their way to the Brazos River Bridge as they waited for word of rescue efforts. In the center, a group of men sit on a rail handcart. A refugee camp was set up by town officials on the east side of the river.

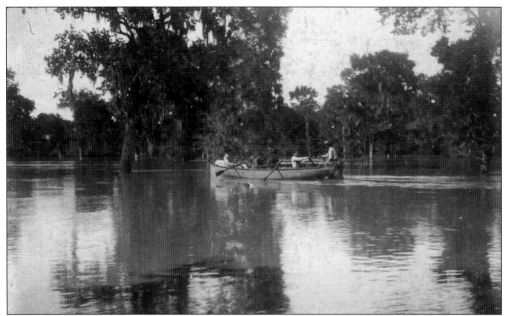

After townspeople gathered at a refugee relief camp away from the flood, several boats went to search for stranded people. This photograph shows the last relief boat, which left camp at 2:00 p.m. on July 7, 1899, and returned at 10:30 p.m. A man identified as Haymen sits in the prow of the boat, and Dudley Bell sits in the stern. The three men in the center of the boat are unidentified. Many people were rescued from trees where they had sought refuge from the raging water. The African American section of town was at a lower elevation and suffered the worst damage.

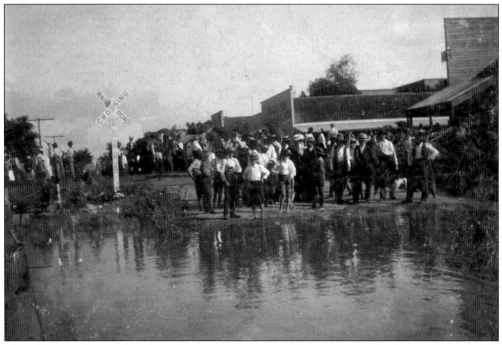

This photograph was taken from a boat carrying a funeral party. Statewide, the number of deaths from the 1899 flood totaled 284.

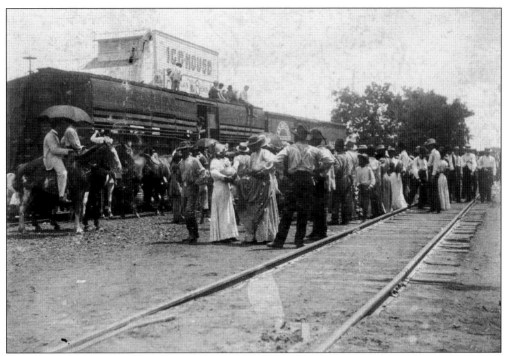

This group of flood victims gathered at the railroad depot to receive watermelons. The icehouse for a local brewery is visible behind the railcars. Dr. Bailey is the man on horseback holding an umbrella at far left.

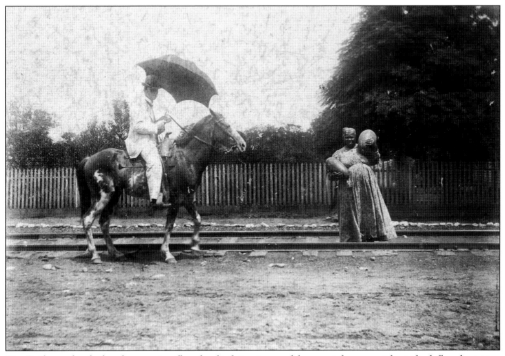

Dr. Bailey, who helped organize flood relief, is pictured here with an unidentified flood victim carrying watermelons.

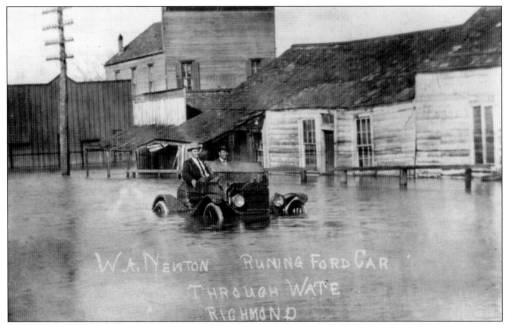

In early December 1913, there was another devastating flood in Richmond. In this image, W.A. Newton attempts to drive his automobile through the floodwaters. Although Richmond citizens suffered property damage, lives were lost in other areas along the Brazos. Waco was hit especially hard. In Belton, in the Brazos River Basin, five members of the Polk family were swept away by a 30-foot wall of water. (FBCL.)

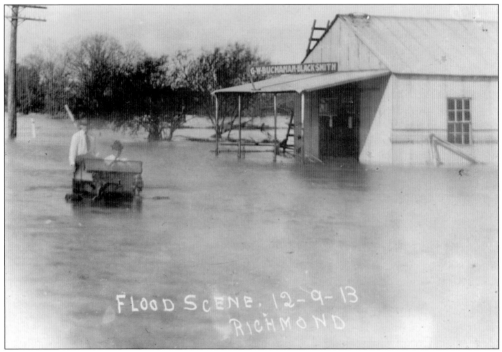

Yet another automobile attempts to drive through the 1913 floodwaters.

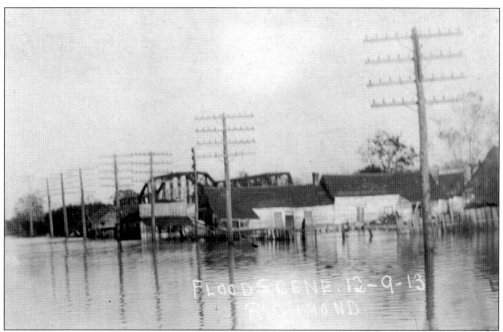

In this photograph of the 1913 flood, the railroad bridge is visible in the background behind the partially submerged homes and utility poles.

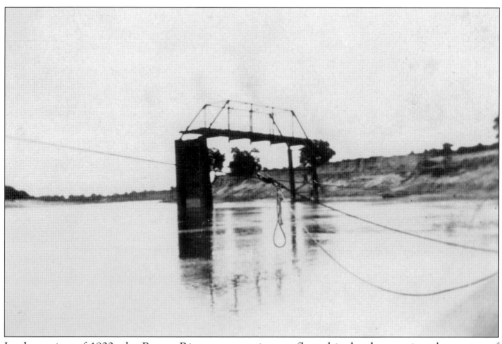

In the spring of 1922, the Brazos River once again overflowed its banks, causing the center of the Brazos River Bridge to collapse and leaving only the approach sections, as shown in this photograph. Once again, Richmond citizens had to rely on a ferry to cross the river. The railroad bridge was left intact, but pedestrians and automobile traffic had no way to cross the river.

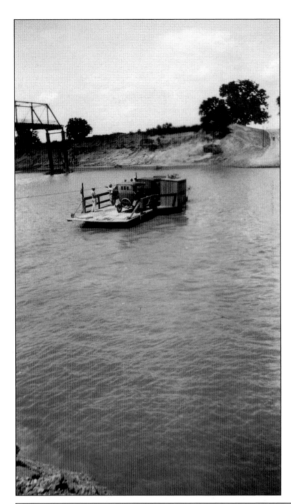

After the collapse of the middle of the bridge in 1922, Fort Bend County authorized the building of a ferry and the hiring of a ferryman. At the same time, they began plans to build a new bridge. In the 1922 photograph at left, the ferry is crossing the Brazos River. For the simple cable ferry, ropes were suspended across the river to guide the vessel. Below, another 1922 image shows the ferry with several people sitting in their automobiles as they cross.

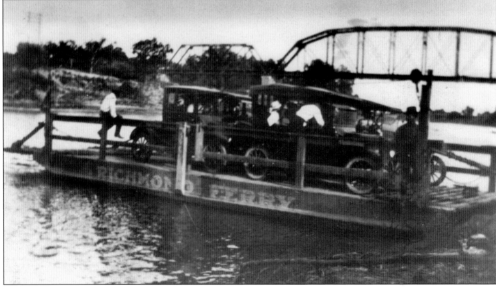

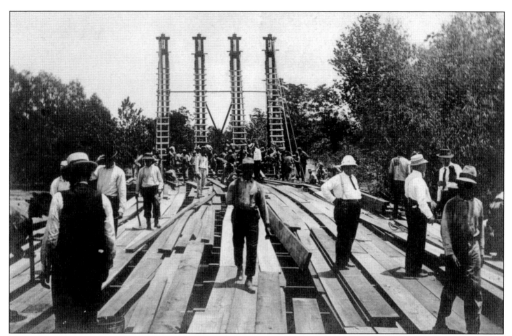

In 1925, construction began on the new Richmond Bridge meant to replace the partially collapsed 1913 Brazos River Bridge. This was the first time the Texas Highway Department used a cantilever truss structure and pneumatic pier construction. The bridge crossed the Brazos River at US Highway 90A. At the time it was built, the 1,156-foot-long bridge boasted the highest masonry piers in the state. The workers in this photograph are laying the base for the 20-foot-wide paved roadbed.

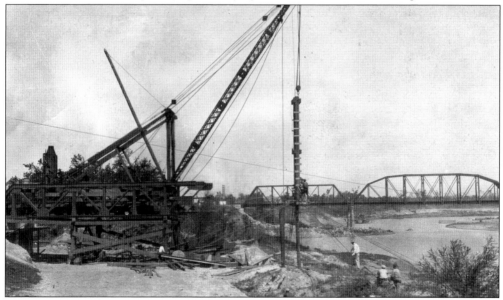

In this photograph, construction of the Richmond Bridge is in progress. The Railroad Bridge is visible in the background. Once completed, this bridge served as an important link between Houston and San Antonio and was also part of the Old Spanish Trail, a national highway that connected Florida to California. The route, completed in 1929, was once one of the most-traveled roads in the South.

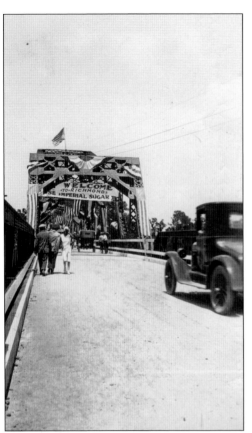

Richmond's new bridge over the Brazos River opened in 1925. This photograph shows the opening ceremonies. Imperial Sugar, based in Sugar Land, Texas, placed a large advertising banner on the bridge that read: "Welcome to Richmond, Use Imperial Sugar."

In 1986, during routine maintenance, structural problems were discovered and inspectors from the Texas State Highway Department determined that the 1925 portion of the Richmond Bridge was no longer safe for vehicular traffic. All traffic was rerouted to the section of the bridge built in 1965. Although many Richmond citizens tried to save the old bridge, hoping to move it to a new location to preserve it, that plan was not to come to fruition. This is the "The World's Greatest Bridge Party," held on November 7, 1987, for Richmond residents to bid a fond farewell to the Richmond Bridge. On July 14, 1988, the bridge was demolished with explosives after 63 years of service to Richmond and the surrounding community. (FBCL.)

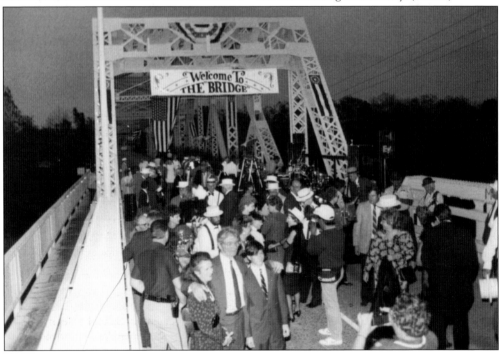

Five

SCHOOLS, CHURCHES, AND CIVIC ORGANIZATIONS

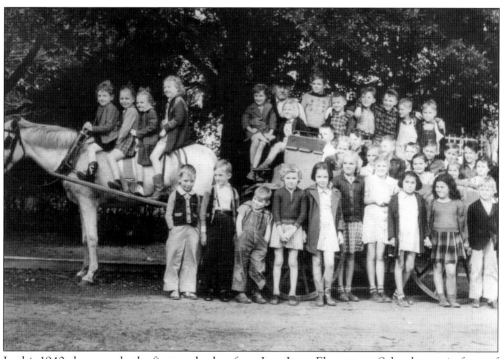

In this 1940 photograph, the first grade class from Jane Long Elementary School poses in front of a wagon after a hayride. A hayride on the "John Leach" wagon was a popular Halloween event. (FBCL.)

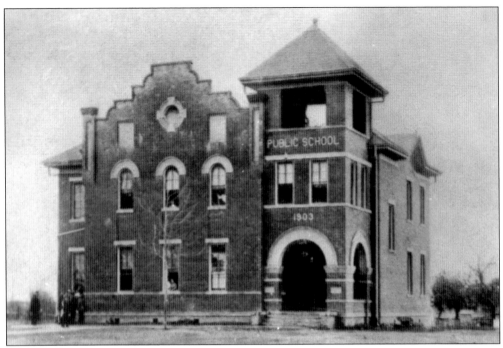

The 1903 Richmond Public School is seen above. In 1840, J.G. McLean advertised his plans to open a school at Richmond "to improve the morals as well as the mind." By 1850, the Richmond Male and Female Academy was in operation, receiving a charter in 1852. The academy continued until 1858, when it went bankrupt. There were four schools in Fort Bend County by 1860, with various name changes over the next four decades. In 1903, a new academy designed by C.H. Page and Brothers architectural firm of Austin was constructed on the former site of the Male and Female Academy and opened as the Richmond Public School. All grades were taught in the same building until Richmond High School was established and Richmond Public School became a grammar school. Richmond High School is pictured below around 1940. (Both, FBCL.)

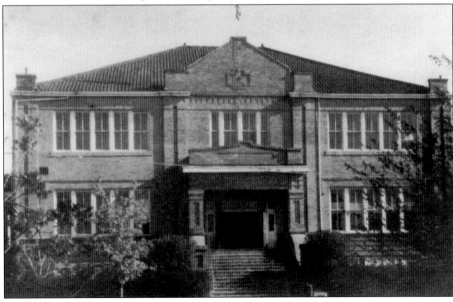

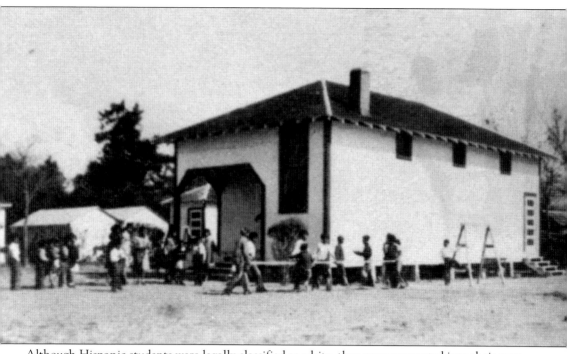

Although Hispanic students were legally classified as white, they were segregated into their own schools across Texas in the early 20th century. Schools for Hispanics were underfunded compared to schools for white students. The League of United Latin American Citizens (LULAC) challenged Texas school segregation in 1930. The Texas Court of Appeals ruled that school districts could look at language and irregular attendance (an issue among Hispanic children because they were often needed to do farm work) to continue to segregate schools. After World War II, the court ruled that students could not be segregated based on Hispanic ancestry. However, many school districts in Texas continued to find loopholes to keep Hispanic children out of white schools through the 1960s. (FBCL.)

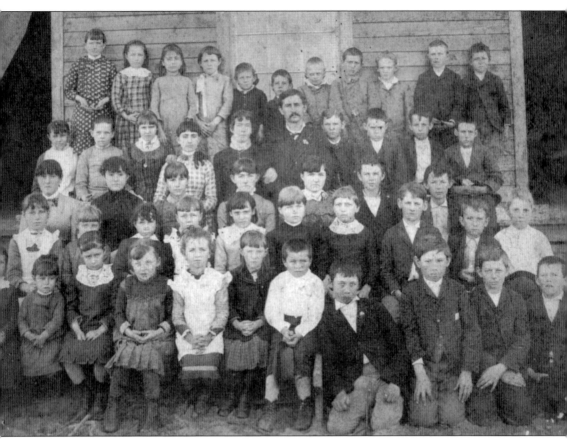

This c. 1887 image shows students at Richmond Public School. They are, from left to right, (first row) Maybell Davis, Winnie McGee, Lilly Rambolt, Mamie Davis, Minnie Waffles, Allie Ogilby, Freddie Kochan, Earl McFarlane, Bush Pleasants, Len McFarlane, and unidentified; (second row) Lizzie McGee, Pearl Winston, Jennie Jones, Annie Somerville, Lyda Baker, Bertie Winston, Lola Jones, Alex Davis, Charlie Andrews, and Will Robinson; (third row) Bessie McCloy, Lillie Winston, unidentified, Nina Bell, Kate Eckman, Heard Dyer, and two unidentified; (fourth row) Minnie Preister, unidentified, Bell Dyer, Julia Norwood, Mrs. Norwood, Professor Norwood, T.B. Wessendorff, John Baker, unidentified, and George Baker; (fifth row) Fanny Lamar, Mary Preister, unidentified, Mattie Bell, Reg. Dyer, unidentified, Cecil Dyer, two unidentified, Albert George, and Bassett Blakely.

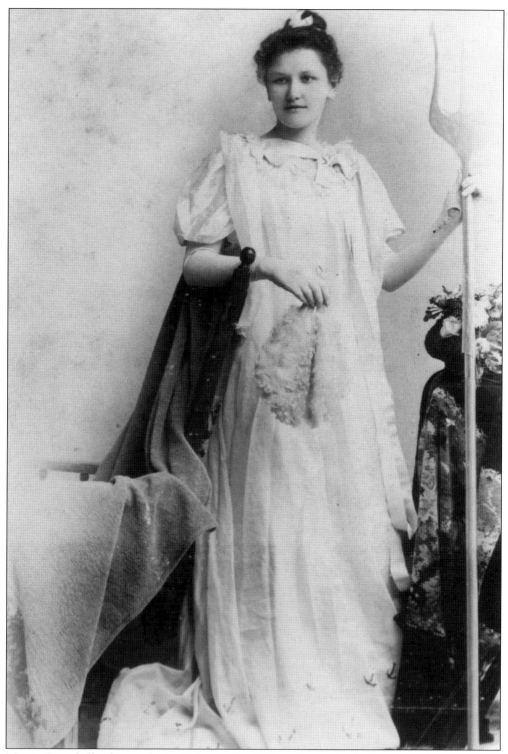

Mattie Campbell, who taught in Richmond in 1894, strikes a classical pose wearing a garment reminiscent of ancient Greece. (FBCL.)

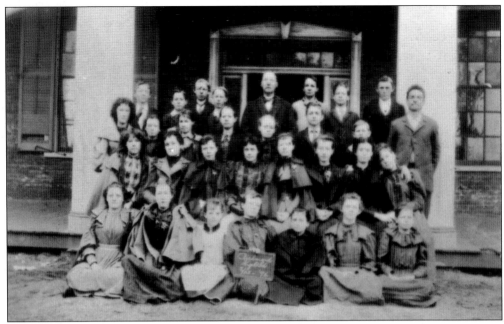

This class picture was taken in February 1896. One of the teachers stands in the center of the back row.

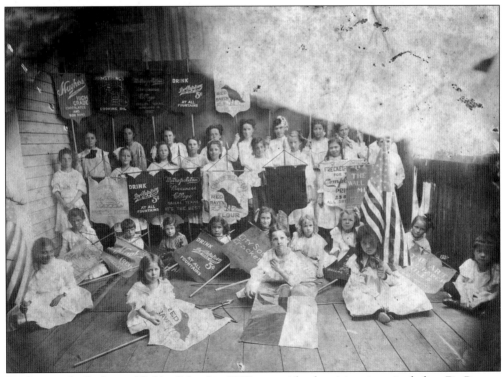

Students at the Richmond Public School in 1908 pose with advertising signs, including Dr. Pepper, Sphinx Oriental Coffee, Metropolitan Business College in Dallas, and Red Raven Flour.

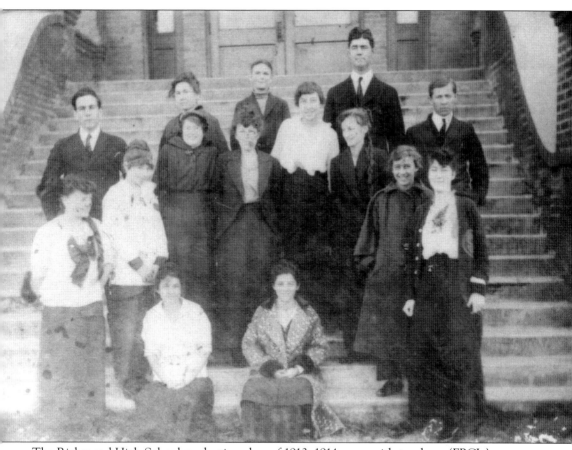

The Richmond High School graduating class of 1913–1914 poses with teachers. (FBCL.)

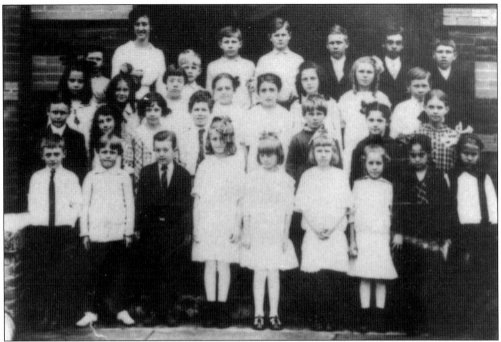

This 1917 photograph shows students from the Jane Long Grammar School. The teacher is in the back row on the far left. (FBCL.)

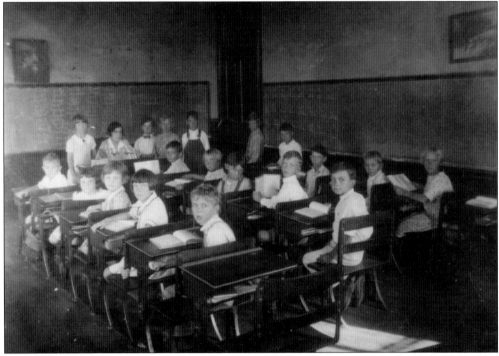

This is a classroom in the Jane Long Grammar School in the late 1920s. A few students have gathered around the teacher's desk, and math problems are visible on the chalkboard at right. (FBCL.)

This first grade class from the Jane Long Grammar School, pictured in 1927, had a teacher named Mrs. P.E. Scott. (FBCL.)

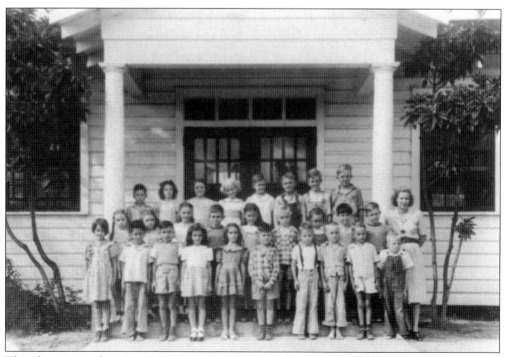

This class picture from Jane Long Grammar School is from the late 1930s. Note that some of the children do not have shoes. (FBCL.)

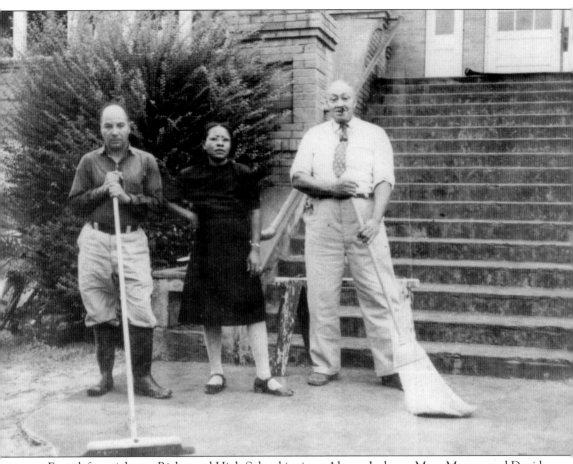

From left to right are Richmond High School janitors Alonzo Jackson, Mary Meyers, and David Meyers. They are standing in front of the school in the early 1950s. (FBCL.)

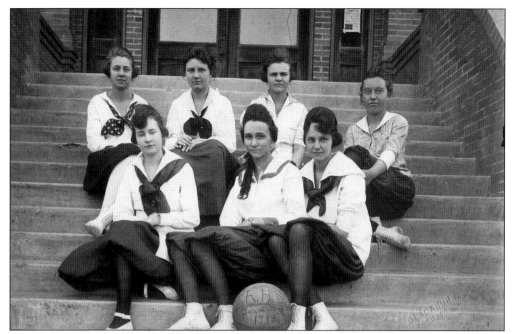

This is the 1918 championship girls' basketball team from Richmond High School. Pictured are, from left to right, (first row) Lucile Rich, Rosalie Daughtery, and Marguerite Wessendorff; (second row) Johnny Winder, coach Margaret Hodges, Aline Austin, and Mary Haggard.

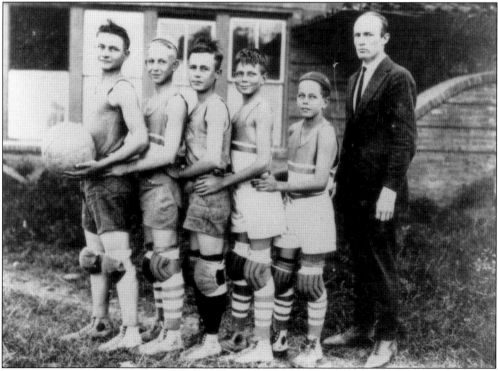

This group of young men is identified as "the high school basketball champions of 1924." Given the size and age of some of them, this may be an intramural team. (FBCL.)

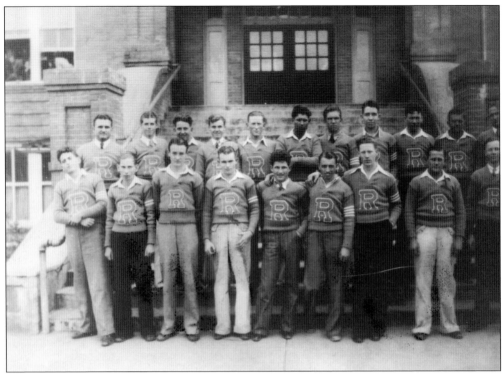

The 1931–1932 Richmond High School football team poses in letterman sweaters on the steps of the school. (FBCL.)

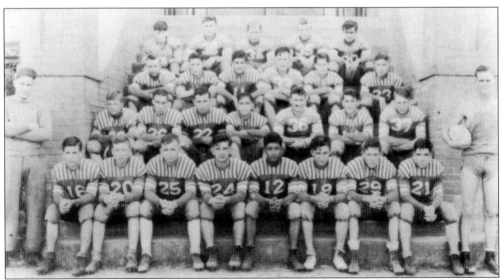

In this 1941 image, the RHS football team sits on the school's entrance steps in uniform. (FBCL.)

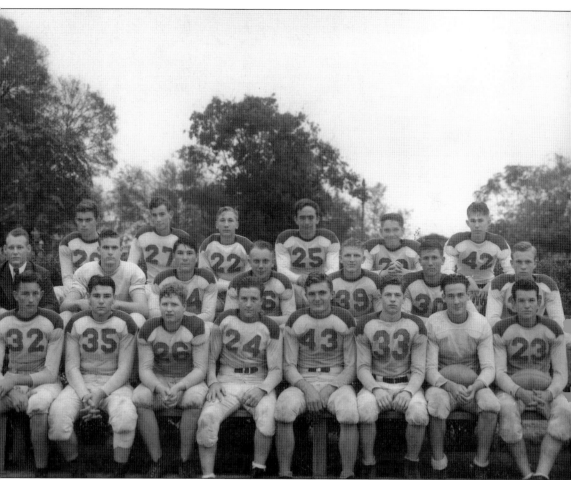

This photograph shows the football team of Richmond High School in the late 1930s. Pictured are, from left to right, (first row) Vit Barta, Hilmar Moore (future mayor of Richmond), Red Wade, Charles Dillon, Theodore Chemelik, Hershal Daily, J.T. Fields, and Bob Davis; (second row) coach Dike Rose, J.T. Moore, Calvin McKennon, Elton Tiemann, Leroy "Red" Hurta, Joe Warney, and E.D. Frazier; (third row) Warren Dozier, George Edward Fields, Allen Vyvial, T.J. Haggard, Andrew Briscoe, and Jessie (Wilson) Speer.

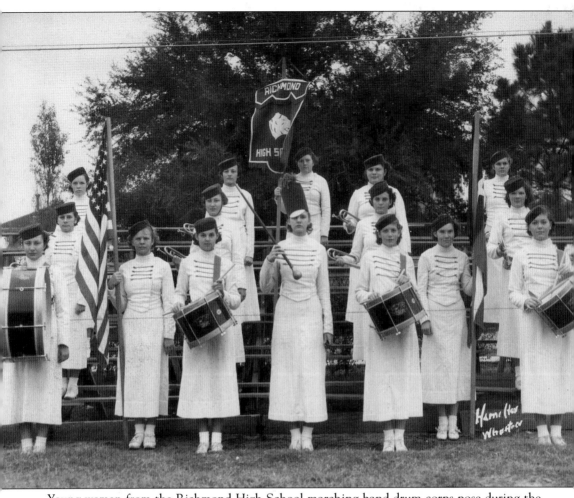

Young women from the Richmond High School marching band drum corps pose during the 1934–1935 school year.

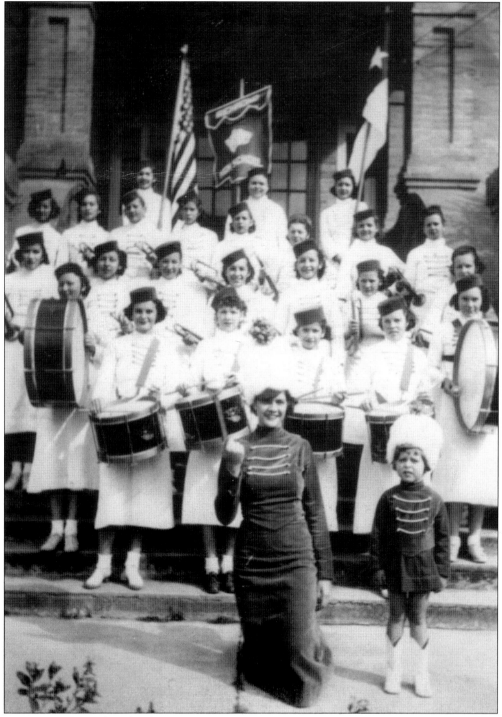

The 1941 Richmond High School band drum and trumpet corps pose behind their drum majorette and junior majorette. (FBCL.)

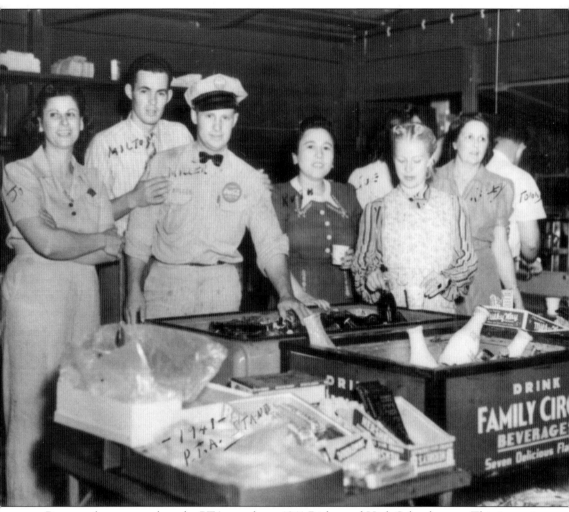

Parent volunteers work at the PTA stand at a 1941 Richmond High School event. This image is most likely from a football game in the fall of 1941. Those pictured had no idea that the United States would soon be plunged into World War II following the December 7, 1941, attack on Pearl Harbor. (FBCL.)

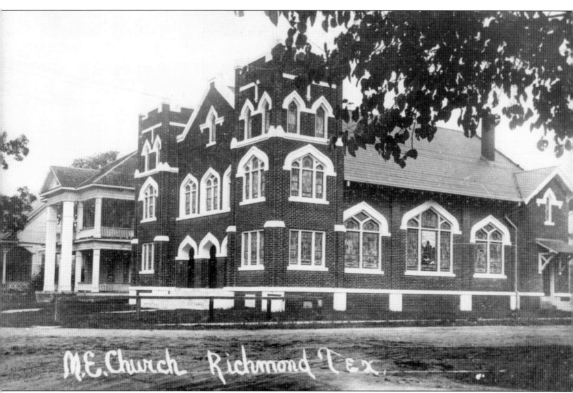

St. John's United Methodist Church, pictured in 1925, was organized in 1839 by Rev. Jesse Hord. The current sanctuary was designed in the Gothic Revival style by Swedish-born architect C.N. Nelson, of Houston, in 1922. In 1929, Nelson was commissioned to design a two-story educational building in the same style as the sanctuary by T.B. Wessendorff in memory of his wife, Jennie. Nelson went on to design Sacred Heart Catholic Church of Richmond in 1935.

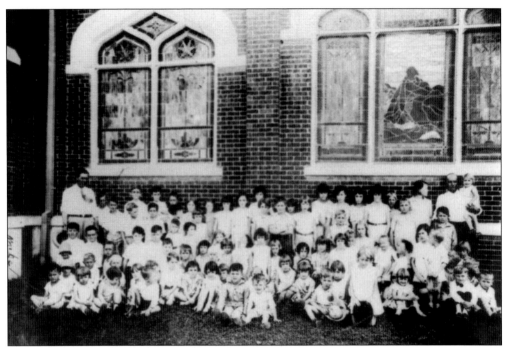

Children pose in front of St. John's United Methodist Church. The church had a large Sunday school program. In the 1870s, Carry Nation, who became infamous for her temperance work, taught Sunday school at St. John's, where she was also a member. (FBCL.)

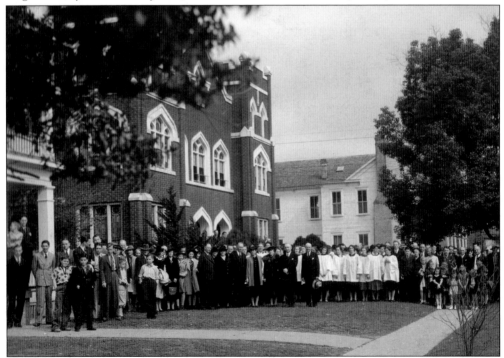

In 1939, St. John's United Methodist Church celebrated its 100-year anniversary. Following a celebratory service, members gathered for this commemorative photograph.

The Calvary Episcopal Church was built in 1859. In 1878, a hurricane destroyed the church. In 1954, the church was relocated and enlarged to include a school. The Calvary School opened in 1956, serving as a kindergarten.

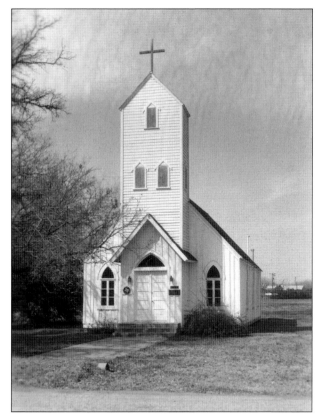

This image shows the front porch of the Episcopal rectory. Mathilde Fletcher stands at right. Her husband, George W., was a local saddle-maker. (FBCL.)

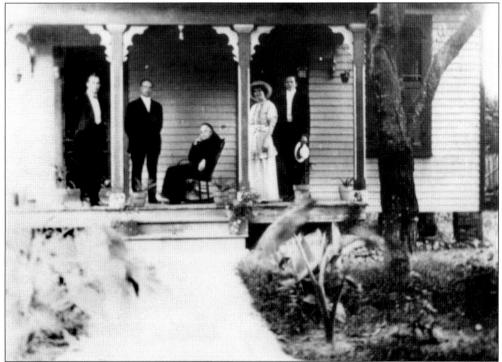

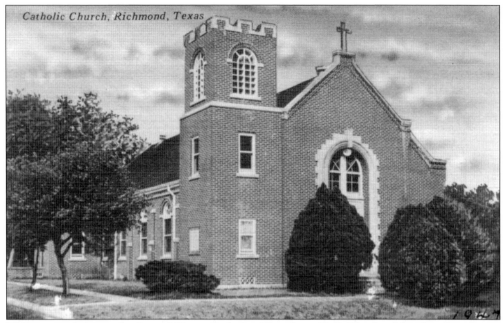

Catholic Church, Richmond, Texas

This postcard shows the Sacred Heart Catholic Church in 1947. The land for this church was purchased by the Catholic bishop in Galveston in 1866. Mass was held in a small chapel and given by visiting priests. In 1868, an Ursuline nun, Madam St. Ambrose, opened a school for about 20 students (only five of whom were Catholic) at the site. In 1901, funds were raised to begin building a church on the site of the chapel, but building did not begin until 1934. Father James K. Reybaud was assigned as the first pastor in February 1935.

Monsignor James J. Madden served at Sacred Heart from 1967 to 1969 and again from 1973 to 1988. Hailing from North Tarrytown, New York, he served as a priest in the Archdiocese of Galveston-Houston for nearly 55 years. Monsignor Madden was one of many devoted priests to minister to the members of Sacred Heart.

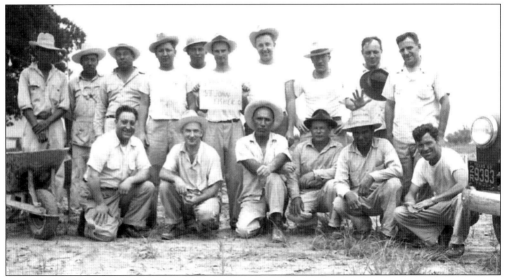

Pictured are local workers and Basilian priests who volunteered to help with the construction of St. John Fisher Catholic Church in 1951. At far left in the first row is Father John Onorato. In the second row from left to right are five unidentified, Father Jack Broussard (holding the sign), Father Fred Sohn, Father Robert Chauvin, unidentified, and Father Leo Adam. The Basilian Fathers originated in France in 1822; by 1899, they had expanded into Texas. In 1900, the Basilian Fathers established St. Thomas College (re-named St. Thomas High School) in Houston. St. John Fisher Church began as a Mass station connected to Our Lady of Guadalupe in nearby Rosenberg in 1950 and remained a mission of that church until 1978, when it was elevated to a parish. (Courtesy of the Basilian Fathers Missions, Sugar Land, Texas)

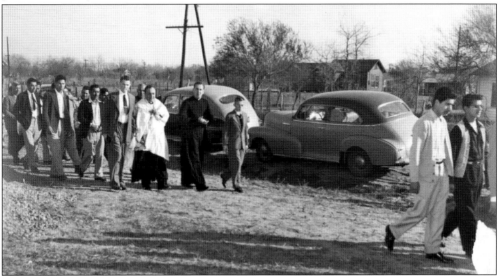

This 1951 image shows the ground blessing ceremony that was held before construction began on St. John Fisher Catholic Church. At the front of the procession in the white robe is Father John Collins. He is accompanied by Father Joseph O'Reilly (black robe) and students from the Aquinas Institute, a Catholic High School in Rochester, New York, who raised funds to help build St. John Fisher. The first pastor of St. John Fisher was Fr. John Pinsonneault. (Courtesy of the Basilian Fathers Missions, Sugar Land, Texas)

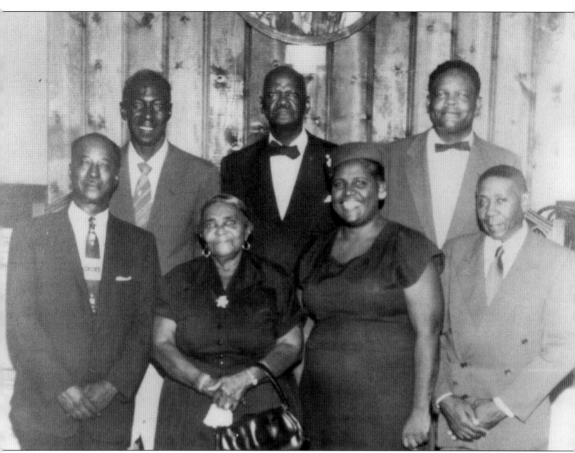

Pictured here in the late 1950s are the trustees of the Mt. Vernon United Methodist Church. Following the Civil War, with cooperation from the Freedmen's Bureau, the Methodist Episcopal Church organized a mission effort to spread through the South to African Americans. Texas fell under the Mississippi Mission. Richmond was among the first locations chosen for a new church. In 1867, the original trustees of Mt. Vernon Church purchased land in Richmond. While waiting for the church to be built, they held services in the school for black children in the "Freedman Town" section of Richmond. The original church, with a seating capacity of 35, was struck by lightning in 1929 and the damage was never fully repaired. When the congregation was ready to build a new church, they decided to build the first brick church for African Americans in Fort Bend County. The trustees in charge of the new building were Lucious Humphrey, Lonnie Davis, Clarence Johnson, A.T. Thomas, and Ben Sanford. The building was completed in 1957. Rev. Alex Crockett was the pastor at the time the new church opened. (FBCL.)

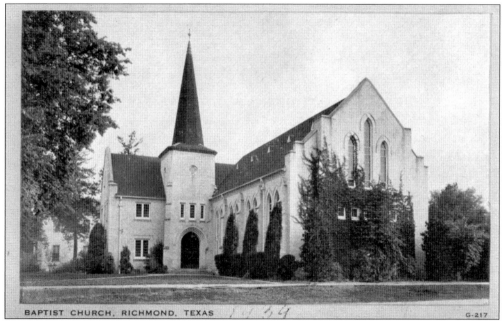

BAPTIST CHURCH, RICHMOND, TEXAS

The First Baptist Church of Richmond began meeting in the home of Lottie Dyer Moore and John M. Moore Sr. in 1885. The family later donated land on which the first church was built in 1889. That building was destroyed in the great 1900 hurricane. The building shown in the postcard was erected in 1930 and designed by architect Alfred Finn. Unfortunately, this beautiful church was destroyed in a massive fire in 1990. (Courtesy of the George Ranch Historical Park.)

Members of the First Baptist Ladies Group are shown around 1925. From left to right are Mrs. Carie Johnson, Mrs. Ida Adams, Fay Lewis (young girl in front), Mrs. Cora Slavin, Mrs. S.L. Cole, Mrs. L.C. Davis, Mrs. Davidson, and Mrs. Susan Elizabeth Davis, who was the wife of banker J.H.P. Davis. Their daughter Mamie married Albert George in 1896 at the church (page 124). (Courtesy of the George Ranch Historical Park.)

This burial monument to Robert Gillespie in Morton Cemetery is believed to be the oldest Masonic memorial in Texas. The marker fell into disrepair, as shown here, and was repaired by the Morton Masonic Lodge No. 72 for the 1936 Texas centennial celebration. A native of Scotland, Gillespie arrived at the home of William Morton, a stranger and fellow Mason, after sustaining injuries during a physical confrontation. Gillespie was cared for in the Morton home until his death on November 7, 1825, and was buried on Morton's property, with the impressive Masonic monument erected later. During the revolutionary war with Mexico, Mexican troops allegedly began to destroy the monument when they came through the area but were ordered to desist by a Mexican officer who was also a Mason. When Michael DeChaumes purchased the property that included the cemetery, the area surrounding the Gillespie grave had evolved into the burial ground for the city. Through an agent in Richmond, DeChaumes sold lots in the cemetery until 1871, when he sold the cemetery to Morton Masonic Lodge No. 72, which managed it as Richmond Masonic Cemetery from 1897 to 1943. Mamie George was instrumental in the preservation and development of the cemetery as a Richmond landmark. In 1934, she purchased land adjoining the cemetery, and in 1944, the property merged with the Richmond Masonic Cemetery to form the Morton Cemetery Association. (Courtesy of Morton Cemetery Association.)

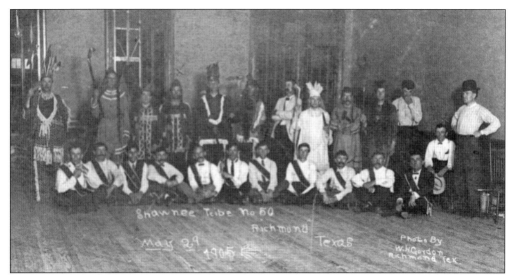

Richmond's Shawnee Tribe No. 50, part of the national fraternal organization the Improved Order of Red Men, poses at a 1905 meeting. The Improved Order of Red Men traces its origins back to the Sons of St. Tammany, a Revolutionary War–era secret society named after a Lenni-Lenape chief who died in 1701. In 1813, the Sons of St. Tammany renamed themselves the Society of Red Men, and in 1834, they added "Improved" to their name. Claiming reverence for the ideals of freedom exhibited by Native Americans, local chapters each adopted a tribe name. The early 1900s saw a large increase in nationwide membership, which swelled to over 500,000 by 1920. During the Depression membership declined, and Shawnee Tribe No. 50 ceased operations. (FBCL.)

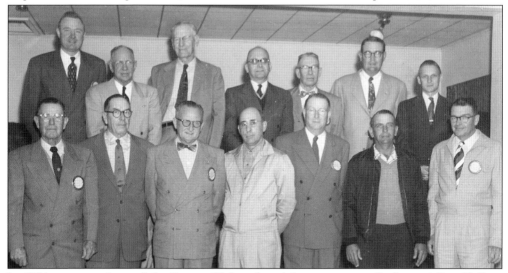

In 1954, past presidents of the Rotary Club gathered for a reunion at Richmond City Hall on Morton Street. All but four of the former presidents were able to attend. In this photograph, they stand in the order of their service, starting in 1936. Pictured are, from left to right, (first row) Joe A. Wessendorff, August Myers, Harry Ellett, W.L. "Bert" Ansel, Glen Birdwell, Roy C. Christian, and Howard Moorehead; (second row) Windel Shannon, Hunter Harris, Walter Minkwitz, Peter Oshman, Ira McCulloch, Joe C. Wessendorff, and Paul Scherer. Tom Fatjo, who served in 1944 and 1945, Lee Grayless (1947–1948), E.W. Grisham (1950–1951), and William H. Graeber (1951–1952) are not pictured.

These young ladies are members of the Audubon Bird Club. They are, from left to right, (first row, on the ground) Marilyn Nichols, Ruby Lois Wendt, Judith Darst and Mary Peareson; (second row, standing) Arlene White, Rosibeth Birdwell, and Minnie Lee Walker. (FBCL.)

Hampton "Happy" Bryan (front) and Stanton Marsh pose in their Boy Scout uniforms in the early 1920s. Hampton's parents were Ben and Gipsy Bryan. (FBCL.)

"Happy" Bryan (left) and two unidentified friends are on their way to a Boy Scout troop meeting in the early 1920s. (FBCL.)

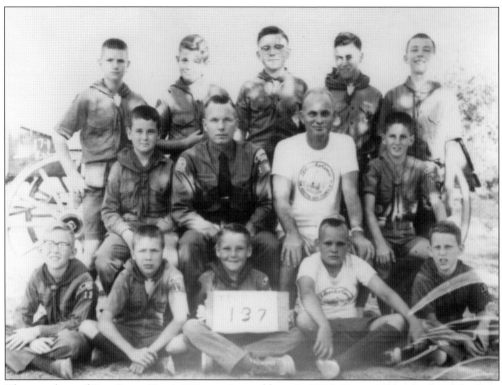

The members of Boy Scout Troop 137 are pictured here in 1964. Troop 137 was part of the Sam Houston Area Council. (FBCL.)

These Richmond men dressed as women during a lighthearted softball game to raise money for a local charity. (FBCL.)

Six

LEISURE

This 1927 photograph was taken in the yard of Lida Davis Moore and James Foster Dyer Moore. Pictured are, from left to right, (first row) Virginia Davis, Antoinette Davis, Mary Jones, Kelley Pearson, Lewis Moore, and John M. Moore III; (second row) Anida Darst, Janice Ransom, Helen Jane Farmer, Bud Collins, Tommie Shufort, Teet McDonald, and Leila Ransom. Antoinette was seven years old, and her sister Virginia was five when this photograph was taken.

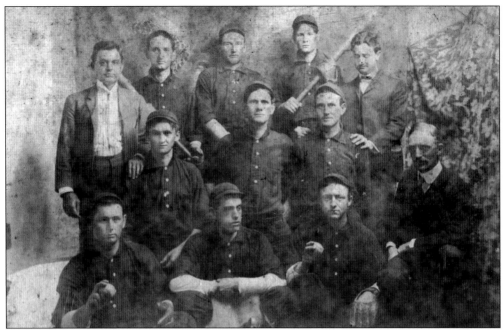

A few of the men on this 1895 Richmond baseball team are identified. In the third row, third from the left is Thomas W. "Bud" Davis; next to him is Bob Wessendorff. In the second row, the two men in the center are Ed and Tom Wessendorff.

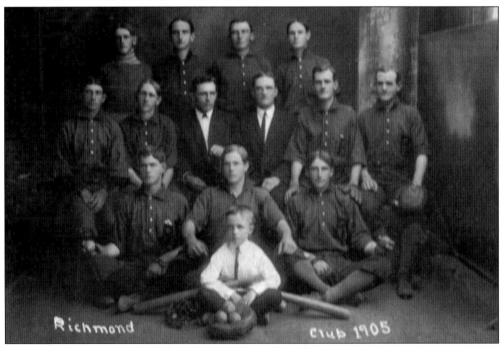

Pictured in this 1905 baseball club photograph are, from left to right, (first row) mascot Willie Nash; (second row) unidentified, Joe A. Wessendorff, and unidentified; (third row) unidentified, Calvin Blakely, Sam B. Cobb, Ed Wessendorff, Tom Wessendorff, and unidentified; (fourth row) two unidentified, Thomas "Bud" Davis, and Bob Wessendorff. (FBCL.)

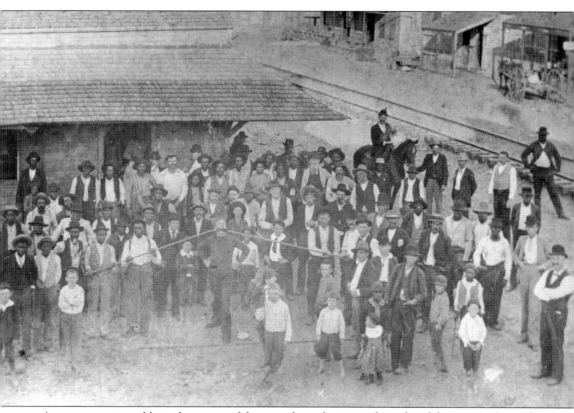

A strong man is visible in the center of this crowd standing near the railroad depot in Richmond. It is likely that he was traveling with the Great Wallace Circus, which visited in November 1896. Often, a few acts would visit a town shortly before the entire troupe arrived to help publicize the performance.

Mary Dell Newton (left) and friends pose in this c. 1910 photograph. Newton was regularly mentioned in the society pages. (FBCL.)

A 1904 parade wagon from Texas Savings and Loan carries local children. (FBCL.)

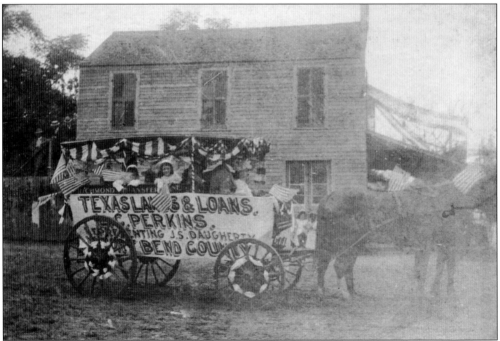

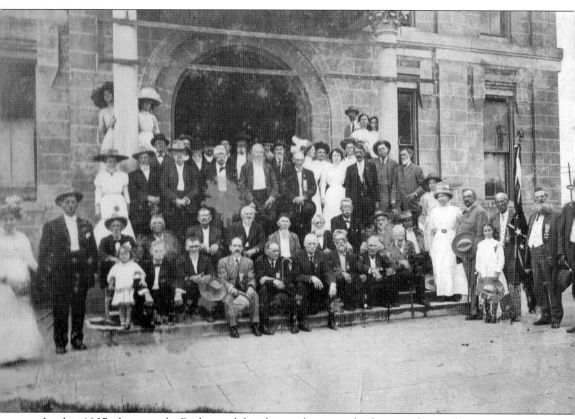

In this 1907 photograph, Richmond families gather outside the courthouse for a meeting of Confederate veterans. A large number of Richmond men served in the Confederate military. Seated at far left in the second row is Virgil Pickney Woolley, father of longtime sheriff M.L. Woolley.

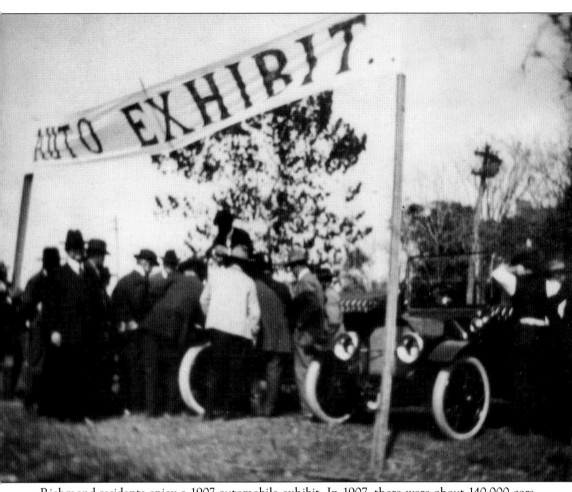

Richmond residents enjoy a 1907 automobile exhibit. In 1907, there were about 140,000 cars registered in the entire United States. In 1907, the first cars with selective transmission became available to consumers. (FBCL.)

Pictured in a 1910 Marion Bobcat in front of the J.T. Dyer store are, from left to right, Bill Jones, Captain Rich, Charles Crawford, Charles Costello, Walter Jones, Thomas W. "Bud" Davis, Earnest Farmer, A.P. George, Martha Hinson, and Joe Jones.

From left to right, Joe Wessendorff, Joe Jones, Emmett Mayfield, Ed Powell, and Earnest Farmer pose with "FIVE HOBOES" written on their shoes. Farmer is holding a pistol. (FBCL.)

In this c. 1917 image, Robert Ransom appears to be about 20 years old. He is posing with his friends, including Philip Peareson. Peareson was a student at the University of Texas in Austin, where he was a member of Kappa Sigma and the University Club. Ransom was the son of Real and Mamie (Wessendorff) Ransom. He was named after his grandfather, who was the first manager of Harlem Prison Farm. (FBCL.)

These four young women posed for this photograph while on vacation around 1905. They are, from left to right, Ivy Moore and her younger sister Mary Dee Moore, Florence Newell, and Inez (Nott) Darst. Inez had recently married Homer Darst when this photograph was taken. Florence Newell was the wife of Matt Moore Newell.

Dorothy Bertrand stands with Lawson Henry in front of a biplane in 1918. Bertrand was a student at the University of Texas in Austin in 1917. She was a member of the Kappa Alpha Theta sorority. These two would soon marry, and in the early years of their marriage they lived with Dorothy's parents, Willie and Willie May Bertrand. (FBCL.)

Pictured from left to right are Lillian Bedford, Bob Bassett, Miss E.J. "Runt" Winston, Edwin Moore, and Eugenia Broussard relaxing after a golf outing. Lillian Bedford was the ladies champion of the Fort Bend Country Club. In addition to being a business owner, Bedford worked as a welder on aircraft carriers during World War II. Eugenia Broussard was a member of the Polly Ryon Hospital Auxiliary and the Richmond Garden Club, and served as secretary for the Fort Bend County Democratic Party. (FBCL.)

Tillie Harper (far left in front row) and Ethel Herzstien (second from right) pose with three unidentified friends. Harper worked as a telephone operator at the switchboard located in the J.H.P. Davis Bank building. In 1930, during the Great Depression, she was still working as a telephone operator and owned a home, which was unusual for a single woman. She later became the head operator, and never married. (FBCL.)

These children are attending a birthday party in 1926. (FBCL.)

Children pose at a summer party in 1927 at the Dyer-Moore home. They are, from left to right, Dorothy Henry, Hilmar Moore, Antoinette Davis, Syd Davis Jr., Lewis Moore, Bud Collins, Mary Jones, Kelley Peareson, and Virginia Davis.

A group of four- and five-year-olds gather for a birthday party in the 1920s. (FBCL.)

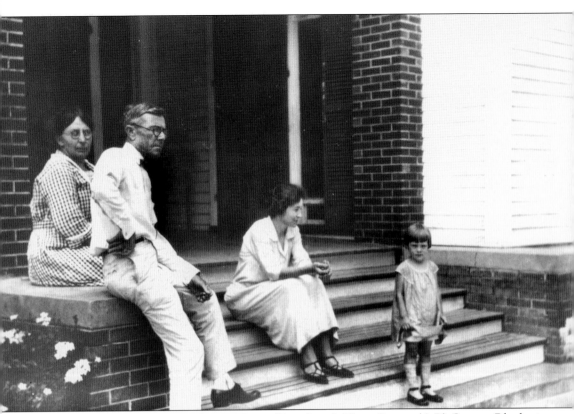

Pictured here from left to right are Mamie (Davis) and Albert Peyton (A.P.) George, Rhydonia Jones, and Mary Jones. Mamie was the daughter of J.H.P. Davis and Susan Elizabeth Ryon. She married A.P. George, who had worked in her father's bank, in 1896. Combined with Mamie's inherited landholdings, passed down from Austin colonist Henry Jones through a succession of female heirs, the couple amassed over 20,000 acres of land. Ranching and oil production enabled the Georges to build a fortune. While Albert was an expert in business and cattle, developing his own breed called the "Brahorn," Mamie used her position to improve the community through myriad philanthropic endeavors. Their infant son, Davis George, died of cholera in 1899. Mary Jones, the daughter of Mamie's cousin, lived at the ranch with her parents during her childhood and was killed in an automobile accident in 1943. Without any immediate heirs, the couple created the George Foundation in 1945 to continue their philanthropy.

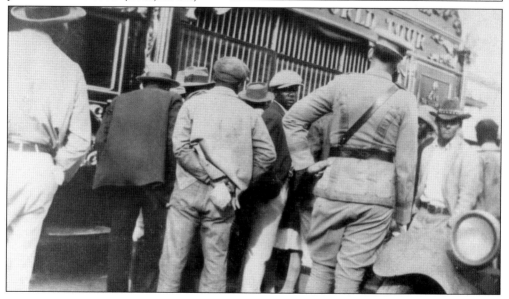

These c. 1930 images show the Metro Goldwyn Mayer (MGM) lion at the Fort Bend County Fair Parade in Richmond. The MGM lion toured various events as publicity for the movie studio. The lion, named Jackie, was the second of the MGM lions to appear on screen and the first to have his roar recorded for the MGM introduction. His other travels were a bit more nerve-wracking than his trip to Richmond. He was in two train wrecks and an earthquake, and survived a sinking boat and a plane crash in Arizona. Jackie retired in 1931. (Both, FBCL.)

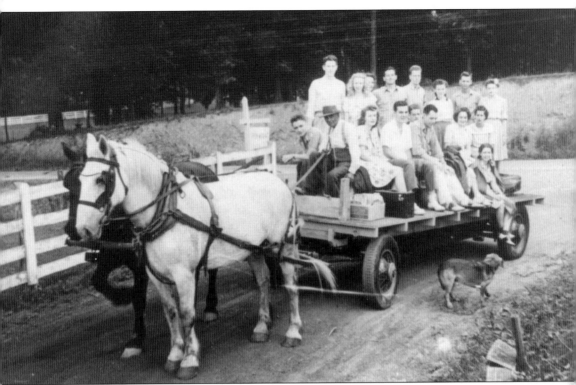

John Leach, a longtime mail deliveryman in Richmond, held an annual picnic and even supplied a hayride wagon. Leach delivered mail for over 20 years. When he retired, he used the old delivery wagon to give hayrides to local children, which was popular for Halloween. In this 1942 image, a group of teenagers enjoy a ride. The tires on the wagon appear to be automobile tires. (FBCL.)